CUTE CH

Mythical Beasts & Magical Monsters

LEARN HOW TO DRAW

Over 60 Enchanting Creatures

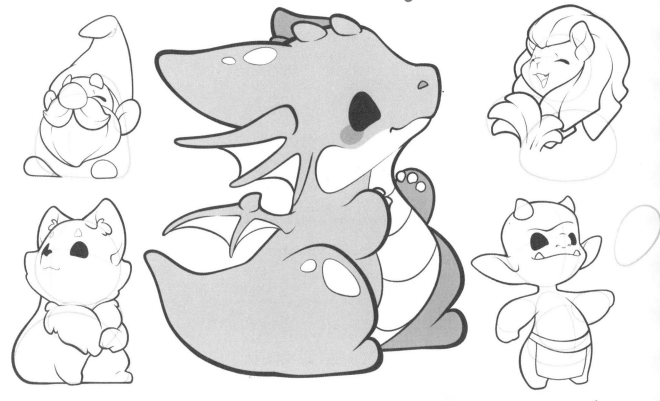

PHOEBE IM

CREATOR OF

BOBBLEJOT

ROCK
POINT

CONTENTS

HOOVES AND HORNS

EARTH, WATER, AND SUBTERRANEAN CREATURES

HELLO!

My name is Phoebe, but I'm also known as Bobblejot. I started drawing at a very young age, but only settled into my current *kawaii* (Japanese for "cute") style of illustrating about two years ago. Last year, I created a webcomic about a corgi dog and a Munchkin cat called *Tori and Samuel*. Since then, I've been creating content for it and sharing it on social media platforms such as Instagram and Webtoon on a weekly basis.

 I was inspired to take the step toward creating a webcomic by a character I created and grew really fond of, and I hope that this book will be able to help you on your road to creating your own set of adorable "chibi" characters and mascots!

WHAT IS CHIBI?

Chibis are most recognizable as mini versions of Japanese-style anime and manga "human" characters. They are defined by their large heads and tiny bodies, both of which contribute to their kawaii, or cuteness, factor. In anime shows and manga comics, chibis are often incorporated into more serious scenes as comic relief. Over the years, chibis have become more diverse, with many different styles of drawing them (i.e., variations in details, anatomy, art style, etc.). Essentially, chibis are kind of like stylized caricatures of regular anime characters; certain facial and anatomical features are exaggerated while maintaining the overall identifying appearance of the character. Here are some key characteristics of chibis:

• A large head and small bodies and limbs.

• Faces with huge eyes and small noses and mouths.

• The hands and feet can be exaggerated to give a more "cartoonish" look.

To draw a chibi animal character, start by taking the key features of the animal and exaggerating them. For example, here's a full-size quetzalcoatl, with normal proportions, standing next to a chibi quetzalcoatl that has the same key features of feathers, wings, a long neck, and an elongated face. The idea is not only to give your chibi quetzalcoatl a larger head and chubbier body (which are common traits of chibi characters), but also to stylize the features that make a quetzalcoatl look like a quetzalcoatl, such as feathers, wings, and the body of a snake.

HOW TO USE THIS BOOK

After some helpful information here in the beginning of the book about Tools and Tips and Tricks for drawing, there are sixty-two step-by-step tutorials divided into four sections: Slither and Squawk, Felines and Canines, Hooves and Horns, and Earth, Water, and Subterranean Creatures.

The creatures within each section are arranged alphabetically, for the most part (there are a few out of order for layout purposes). Some tutorials are even accompanied by a Folklore Fact, making this book not only an art book, but also a little educational. Let's get started!

TOOLS

For your own illustrations, feel free to use any medium you're comfortable with! For all the illustrations in this book, I used the MediBang Paint software for iPad Pro, but you can create the same illustrations with traditional tools like pencils, pens, markers, or anything else you may have handy.

TRADITIONAL TOOLS

If you're drawing your cute creatures with traditional tools, draw all your steps with a pencil first and only go over your drawing with ink right before you're ready to color your artwork. The guidelines you will see throughout the step-by-step tutorials are meant to be erased once the inking is done, so be sure to do that before adding your colors! Also, you may want to invest in a high-quality eraser that will get rid of all those pencil lines.

1. Sketch and draw your character with a pencil.

2. Only use ink once you're happy with your final drawing. Erase any guidelines and then add color.

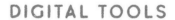

DIGITAL TOOLS

If you're drawing on your desktop or laptop, Adobe Photoshop, PaintTool SAI, and Clip Studio Paint are just some of the recommended software programs for artists. If you're like me and prefer using your iPad to create your illustrations, MediBang Paint and Procreate are just some of the tools that are intuitive and equipped with a wide variety of brushes and functions to help you create your artwork.

TIPS AND TRICKS

In this section, I share my tips and tricks for drawing, inking, coloring, shading, and highlighting chibi creatures.

SKETCHING AND DRAWING To contribute to the cuddly and cuteness factor of your chibi creatures, keep your shapes and lines nice and loose rather than sharp and angular. This means adding curves to your lines and rounding the points and corners of shapes like triangles and trapezoids.

FACIAL GUIDELINES When drawing a character's face, adding guidelines to show where the character is facing helps to position facial features, such as the eyes, nose, and mouth. As shown in the example below, the eyes should be centered on the horizontal guideline, the nose should be placed where the guidelines meet, and the mouth should be aligned with the vertical guideline.

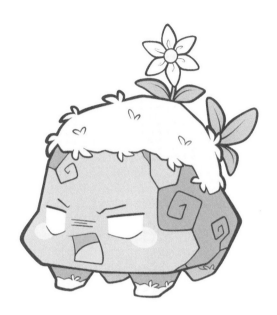

FACIAL EXPRESSIONS

Giving your character different facial expressions adds personality and makes them feel more relatable.

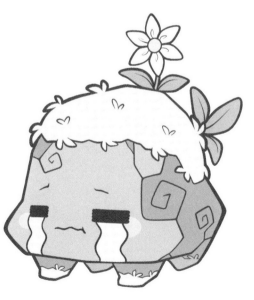

INKING LINES

When it is time to ink your character, drawing with consistently thin lines can make the final outline look a little flat.

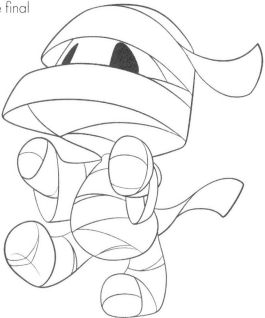

Varying the thickness of your lines helps make the illustration feel more organic and interesting.

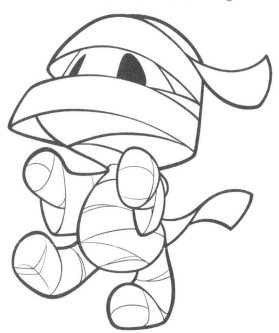

COLORING

In this book, you will learn how to draw chibi creatures, but if you would like to color your characters, here's how you can add color to your drawing after you've inked your character.

1. Start with your inked creature.

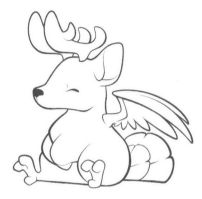

2. Add any distinctive markings to your character. Make sure to draw these markings in pencil, if you're drawing by hand, or on a separate sketch layer, if you're drawing digitally. You will erase/remove these lines when you're finished coloring in the markings.

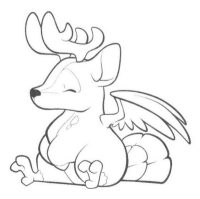

3A. If you're coloring your artwork by hand, with colored pencils, Copic markers, or watercolors, fill in the sections with the different colors.

3B. If you're coloring your artwork digitally, fill in the overall outline with the character's most basic color. You can then add the colors for the markings layer by layer.

SHADING

Shadows depend on where the light is coming from. In the example below, the light source is coming from the top left. The colored spheres next to each character below show how the shadow is cast based on where this light source is positioned.

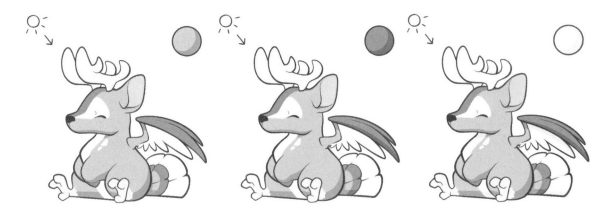

HIGHLIGHTING

For some characters with more reflective skins or textures, you'll want to add a little shine to the parts that are closest to the light source. As you can see with the example of the cthulhu, the surfaces facing the light source are highlighted with a brighter color, while the shadows behave in the same way as in the Shading section above.

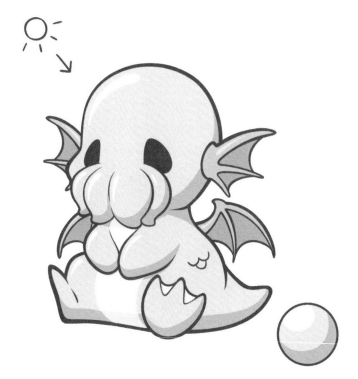

ACCESSORIZING

Once you're done drawing and coloring your characters, feel free to give them some cute clothes and accessories! Because of a chibi's small stature, the best rule is to keep these items somewhat simple. For example, you can add a detail like a huge button to a bag or a basic pattern on a T-shirt, as long as it doesn't make the item look too cluttered.

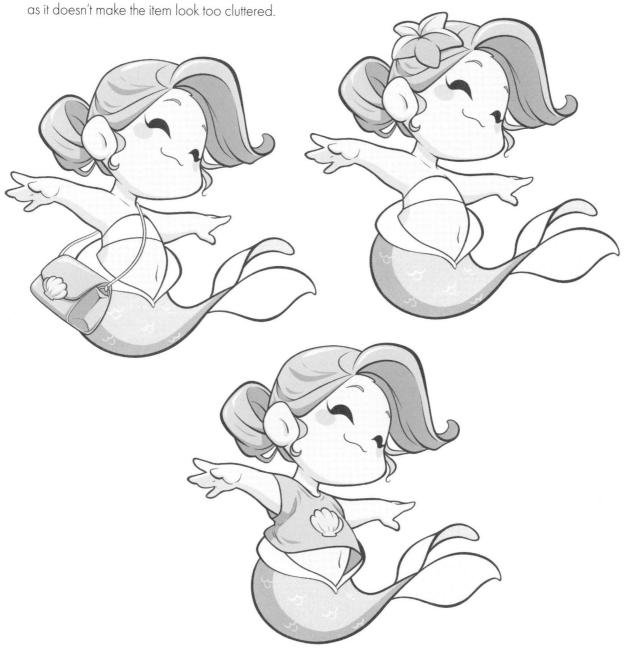

CREATURE KEY

SLITHER AND SQUAWK

AQRABUAMELU
Also known as Scorpion Man, these creatures are described to have the head, torso, and arms of a man and the body of a scorpion.

BASILISK
The Basilisk was a giant serpent, also known as the King of Serpents.

COCKATRICE
The Cockatrice is a legendary two-legged reptilian with a chicken's head atop a dragon's body.

CTHULHU
Created by author HP Lovecraft, the Cthulhu is a half-human, half-beast known to have the head and face of an octopus, the wings of a dragon, and claws as sharp as knives.

DRAGON
Dragons are serpent-like creatures with four legs, large wings, and a crested head, known most for their ferocity and fire-breathing capabilities.

GRIFFIN
Griffins are known to be part eagle and part lion—having the head, torso, and wings of an eagle, and the tail and hind legs of a lion.

HARPY
The Harpy is a legendary creature known to be half-woman and half-bird, with the body of a woman and the legs and wings of a bird.

HIPPOCAMPUS
The Hippocampus is described as a horse-like creature with the tail of a fish.

HYDRA
The Hydra is a water serpent with many heads—which can range from three to nine in total—known most as a swamp dweller and guard for the underworld in Greek mythology.

MEDUSA
Known as one of the three Gorgon sisters, Medusa is recognized as a woman with a serpent's tale and hair comprised of snakes.

MOTHMAN
A member of contemporary American folklore, Mothman is known as a large black creature with red eyes and wings.

NAGA
Naga is known to be part human, part cobra, known most for its beautiful humanoid features and serpent's tail.

PHOENIX
The Phoenix is a red-winged bird, known for its immortality, fire-like wings, and direct connection to the sun.

QUETZALCOATL
Quite comparable to a dragon, the Quetzalcoatl is a flying feathered serpent known to be a powerful and protective deity in Mesoamerican culture.

WYVERN
A wyvern is a small, dragon-like creature, with two legs rather than four.

FELINES AND CANINES

ARALEZ
An Aralez is a winged dog with the powers to heal.

CERBERUS
The Cerberus is a three-headed canine, known as the guard of the underworld.

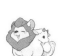
CHIMERA
Serving as another multi-animal blend, the Chimera is a three-headed creature with the head of a lion up front, the head of a goat in the middle, and the head of a dragon from the back.

CÙ-SÌTH
The Cù-sìth is a legendary member of Scottish folklore, known for its braided tail, menacing dog-like features, and its strong physique.

ENFIELD
The Enfield is a fox-like creature, with the head of a fox, the body of an eagle and the legs of a wolf.

KITSUNE
Known as the Japanese nine-tailed fox, the Kitsune is identified as a trickster with paranormal abilities and extreme intelligence.

KLUDDE
The Kludde is a large dog with batwings, known for its shapeshifting abilities and vicious spirit.

MANTICORE
Similar to the Egyptian Sphinx, the Manticore is a beast with the head of a human or lion, the body of a lion, and the tail of scorpion.

MERLION
As implied by the name, the merlion is half-lion, half-fish.

NEKOMATA
The Nekomata is a two-tailed cat that lives in the mountains.

ORTHRUS
The Orthrus is a two-headed dog with a serpent's tail. He is related to Cerberus.

SPHINX
The Sphinx is a mythological creature with the head and chest of a woman, large bird-like wings, and the body of a lion.

TATZELWURM
The Tatzelwurm is a half-cat, half serpent beast.

WEREWOLF
The werewolf is a beast that is half-man, half-wolf, known to transform at the rise of a full moon.

HOOVES AND HORNS

CATOBLEPAS
Catoplebas is a boar-like monster who is said to resemble a water buffalo with an extremely heavy head.

CENTAUR
A centaur has the upper body of a human and the torso and lower body of a horse. They are hyperintelligent.

CUYANCÚA
A mythical being of great size and strange appearance, the lower half of a cuyancúa body is shaped like a snake and the upper half is shaped like a pig.

HIPPALECTRYON
A hippalectryon is a hybrid creature of Ancient Greek folklore, half-horse and half-rooster, it can communicate with both horses and birds.

ICHTHYOCENTAUR
Ichthyocentaurs are centaurine sea beings with the upper body of a human, the lower anterior half and fore-legs of a horse, and the tailed half of a fish.

JACKALOPE
Born of North American folklore, this fearsome critter is a hybrid with the body of a jackrabbit and the horns of an antelope.

MINOTAUR
Known for their superhuman strength, minotaurs have the head and tail of a bull and the body of a man.

OPHIOTAURUS
Ophiotaurus, meaning serpent-bull, was a powerful creature that had the head and front legs of a black bull and the tail of a snake.

PEGASUS
A mythical and divine winged horse, Pegasus is one of the most recognized creatures in Greek mythology.

QILIN
Also known as the Chinese unicorn, Qilin symbolize good luck and prosperity.

SATYR
Described in Greek mythology as a man with the tail, ears, and legs of a horse, Satyr are known as a mischievous Nature Spirit.

UNICORN
A unicorn is reputed to be a magical and beautiful horse-creature with a single horn on their heads.

EARTH, WATER, AND SUBTERRANEAN CREATURES

BIG FOOT
Also known as Sasquatch, Bigfoot is an ape-like humanoid creature said to inhabit the forests of North America.

CECAELIA
In Asian and North American folklore, Cecaelia is described as an "octopus-woman."

CYCLOPS
In Greek legend, cyclops is a one-eyed giant with superhuman strength.

ELF
Elves are a slim, magical, human-like creature with leaf-shaped ears.

FAIRY
Although there are many classes of fae, fairies are most commonly known to be small, beautiful, winged women that have a wide range of enchanting powers.

GENIE
Traditionally called Djinn, genies inhabit inanimate objects such as a golden lamp, and often appear as a man emerging from a whisp of smoke.

GNOME
Only about one foot in height, and wearing a tall red hat to appear taller, gnomes are seven times stronger than a man.

GOBLIN
Goblins are a type of European fairy but more closely resemble a demon with flat faces and pointed ears.

LOCH NESS
Nicknamed Nessie, the Loch Ness monster is described by the Scottish as a shy plesiosaur-like creature with a long neck and humps protruding from the water.

GOLEM
A golem is an anthropomorphic being in Jewish folklore that is made entirely from natural materials from the earth.

IMP
An imp is a being that is similar to a dark fairy with devil-horns and wings and a mischievous spirit.

KAPPA
Kappa, meaning "river child," inhabit the rivers of Japan and are described as being built for swimming with their webbed hands and feet and a turtle-like beak and shell.

LEPRECHAUN
In Irish folklore, leprechauns are usually described as a short man with a red beard and lucky-green clothes. They have great coffers of gold and are practical jokers.

LEVIATHAN
Leviathan, or Livyatan in Hebrew, was a primordial sea serpent dragon hybrid in Jewish mythology.

MERMAID
Mermaids are legendary creatures with the upper body of a beautiful woman and the tail of a fish. Males are known as "mermen."

MUMMY
In ancient Egypt, mummies are deceased pharaohs that are ceremoniously wrapped and decorated so that the kings can rise from the dead.

TREANT
The treant came into being when a millennia-old tree was inhabited by a fairy-like spirit.

KRAKEN
The kraken is a massive squid-like creature with long tentacles that can pull ships to the depths of the ocean.

VAMPIRE
In European folklore, vampires are undead creatures that use their sharp fangs to pierce the skin of their victims and drink their blood, which gives them eternal life.

WENDIGO
In Canadian folklore, a wendigo has animal-like ears, a horn protruding from its head, and has herculean strength.

YETI
A yeti is a folkloric ape-like creature that is similar to a bigfoot, but rather than forest-dwelling, they inhabit the Himalayan Mountains.

SLITHER AND SQUAWK

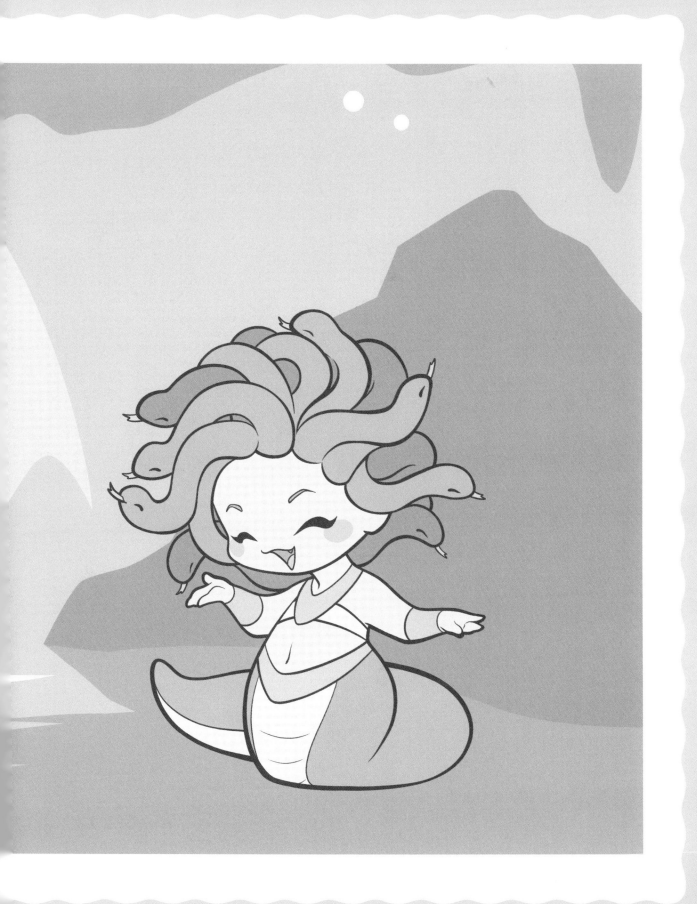

AQRABUAMELU

1.

Draw an egg shape for the head and add guidelines for the facial features.

2.

Draw a smaller egg shape below the head for the torso and add an oval shape below it for the lower half of the body.

3.

Add a small egg shape next to the torso and draw two curves connecting it to the lower half of the body for the tail.

4.

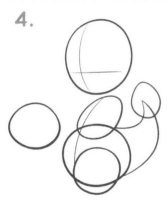

Draw two circles around the lower half of the body for the claws.

5.

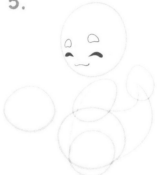

Draw in the facial features.

6.

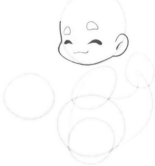

Outline the face.

7.

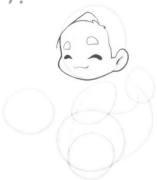

Add the hairline and give the character a fringe.

8.

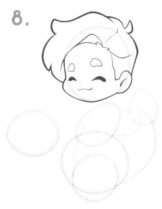

Draw the hair.

9.

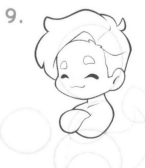

Using the torso guidelines, draw the upper half of the body.

10.

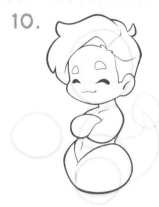

Draw the lower half of the body.

11.

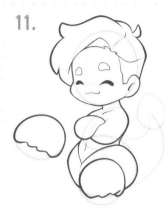

Follow the guidelines and draw the upper half of each claw.

12.

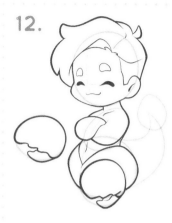

Add in the lower half of each claw.

13.

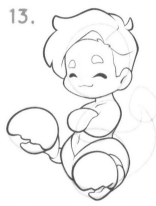

Connect the claws to the lower half of the body.

14.

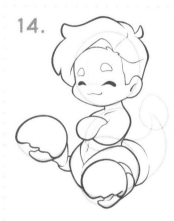

Draw a segment of the tail.

15.

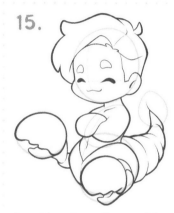

Repeat the pattern until you reach the end of the tail.

16.

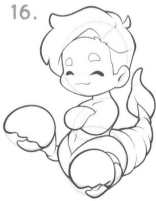

Using the guidelines, draw the end of the tail, then erase your guidelines.

17.

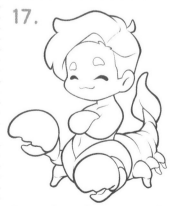

Draw in a few smaller legs on one side of the body, and one leg on the other side.

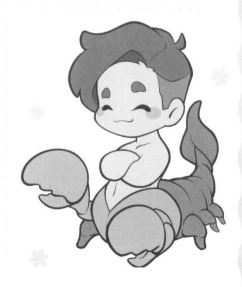

BASILISK

1.

Draw an egg shape for the head and add guidelines for the facial features.

2.

Draw a smaller egg shape by the front of the face for the nose and add a larger oval below for the body.

3.

Draw in the facial features.

4.

Outline the face.

5.

Add horns to the top of the head.

6.

Using the guidelines, draw the body.

FOLKLORE FACT: *Known as the most poisonous creature alive, the basilisk's gruesome breath kills off plants and trees and shatters stone.*

7.

Extend two curves back to the head for the neck.

8.

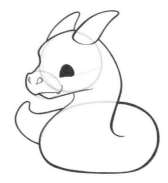

Draw the tail.

9.

Draw curves outlining the belly of the basilisk. Erase your guidelines.

10.

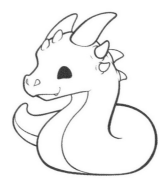

Add smaller scales and horns to the head.

11.

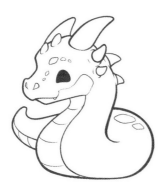

Add some final details to the character.

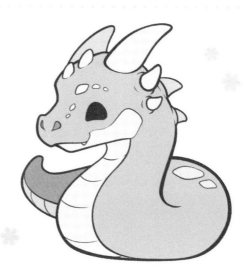

COCKATRICE

1.

Draw an egg shape for the head and add guidelines for the facial features.

2.

Add a large oval shape below for the body.

3.

Extend two curves from each side of the body and add two arcs underneath for the wings.

4.

Draw in the facial features.

5.

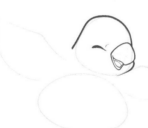

Outline the head.

6.

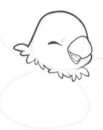

Add feathers around the neck.

7.

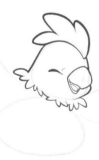

Add the comb.

8.

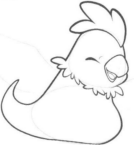

Using the guidelines, draw in the body and add a tail to the back.

9.

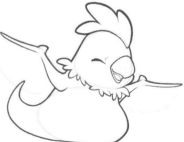

Draw the upper half of the wings.

10.

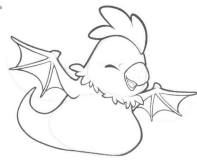

Draw the lower half of the wings.

11.

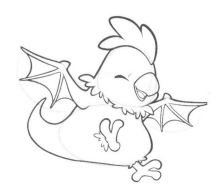

Draw the feet.

12.

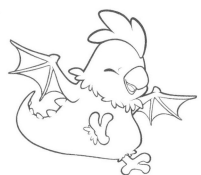

Add scales along the back and tail of the cockatrice, then erase your guidelines.

13.

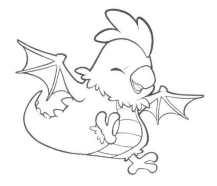

Add some final details to the character.

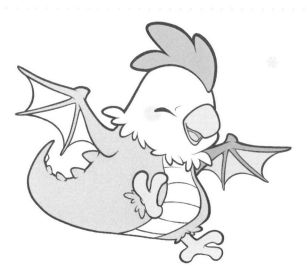

CTHULHU

1.

Draw a circle for the head and add guidelines for the facial features.

2.

Add an oval shape to the lower front half of the face for the tentacles around the mouth and another larger oval shape below the head for the body.

3.

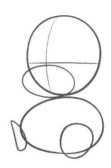

Add an oval shape and half an oval shape to the body for the feet.

4.

Sketch out the general shape of the tentacles around the mouth area.

5.

Complete the tentacles.

6.

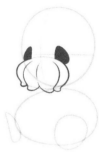

Draw in the eyes.

7.

Outline the head.

8.

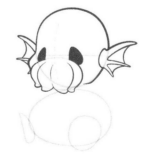

Add fins to the side of the head.

9.

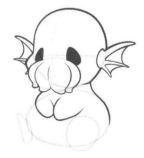

Draw in the upper half of the body

10.

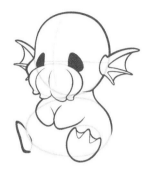

Draw the feet.

11.

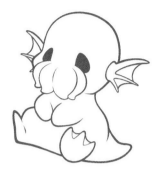

Draw the rest of the body and the tail and erase your guidelines.

12.

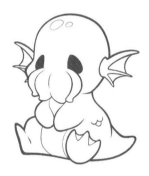

Add some final details to the character.

13.

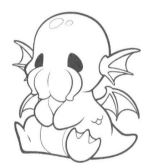

Draw the wings.

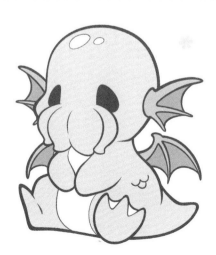

DRAGON

1.

Draw an egg shape for the head and add guidelines for the facial features.

2.

Add an egg shape to the front of the face for the nose and another larger one below the head for the torso.

3.

Draw an egg shape and half an egg shape on each side of the body for the legs.

4.

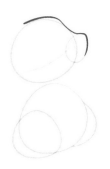

Outline the forehead and nose of the dragon.

5.

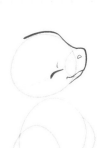

Draw in the facial features.

6.

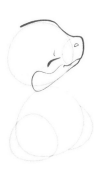

Outline the jaw of the dragon.

7.

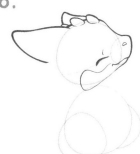

Add horns to each side of the head.

8.

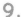

Add scales to the top of the head.

9.

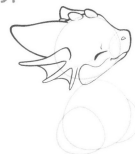

Add fins to the side of the head.

10.

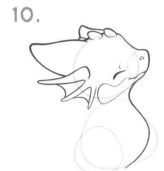

Draw the belly.

11.

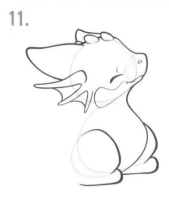

Draw the legs and feet.

12.

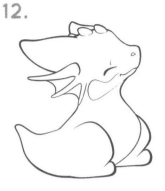

Complete the body by drawing in the tail and erase your guidelines.

13.

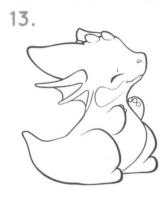

Draw the arms.

14.

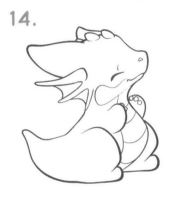

Add scales to the belly.

15.

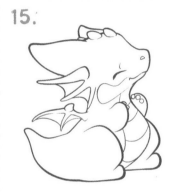

Draw the wings.

16.

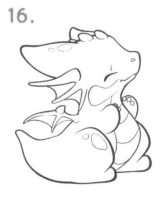

Add some final details to the character.

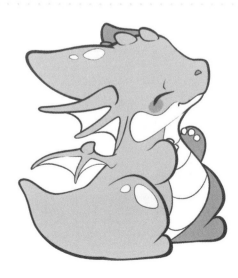

GRIFFIN

1.

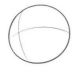

Draw a circle for the head and add guidelines for the facial features.

2.

Draw an oval shape below the head for the body.

3.

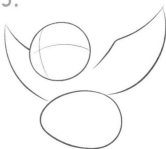

Extend two curves from each side around the neck area and add two arcs underneath.

4.

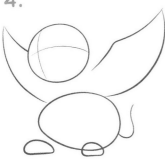

Add two half oval shapes right at the base for the feet and a curve at the back for the tail.

5.

Draw in the facial features.

6.

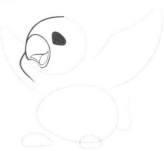

Outline the face.

7.

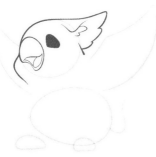

Add some feathers to the side of the head.

8.

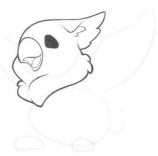

Draw some neck feathers.

9.

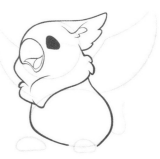

Outline the body.

FOLKLORE FACT: Griffins are said to have the strength of a lion, the sharp eyesight of an eagle, and can fly great distances.

10.

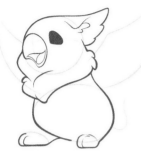

Draw the feet.

11.

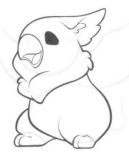

Draw the legs.

12.

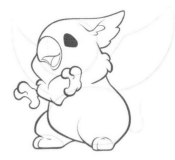

Draw the claws.

13.

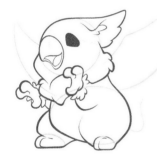

Add feathers around the claws.

14.

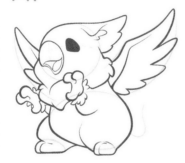

Draw the wings and erase your guidelines.

15.

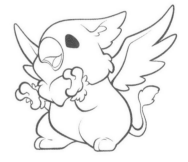

Draw the tail.

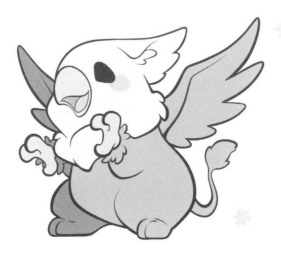

HARPY

1.

Draw an egg shape for the head and add guidelines for the facial features.

2.

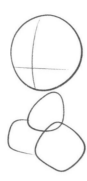

Draw another smaller egg shape below the head for the torso and two rounded diamond shapes for the legs.

3.

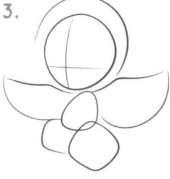

Extend two curves from each side of the torso and add two arcs underneath for the wings. Draw an arc above the head.

4.

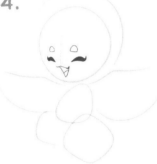

Draw in the facial features.

5.

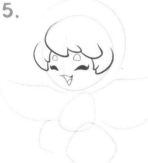

Draw the fringe.

6.

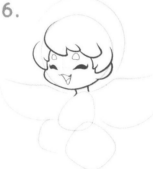

Outline the face.

7.

Add locks of hair emerging from a single point around the top of the head.

8.

Add more locks of hair to the top.

9.

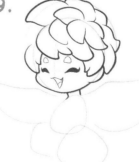

Add locks of hair to the back.

10.

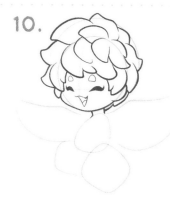

Add locks of hair to the front.

11.

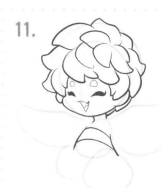

Draw the torso.

12.

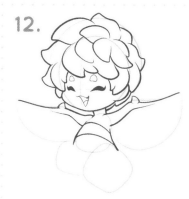

Draw the upper half of the wings.

13.

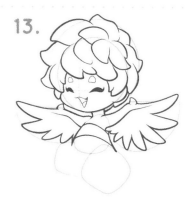

Following the arcs, draw the lower half of the wings.

14.

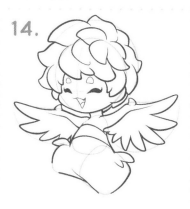

Draw the legs and erase your guidelines.

15.

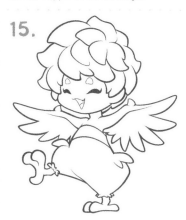

Draw the feet.

16.

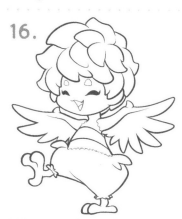

Add separations between the wings, thighs, and the torso.

HIPPOCAMPUS

1.

Draw a circle for the head and add guidelines for the facial features.

2.

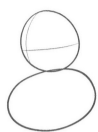

Draw a long oval shape below the head for the body.

3.

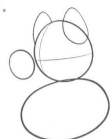

Add a circle to the front of the face for the nose and two egg shapes on each side of the head for ears.

4.

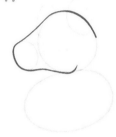

Using the guidelines, outline the head.

5.

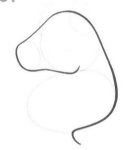

Extend a curve down to the body.

6.

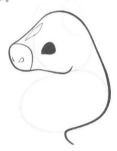

Draw in the facial features.

7.

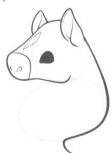

Draw the ears.

8.

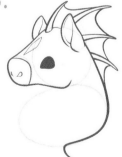

Draw fins along the top of the head down to the neck.

9.

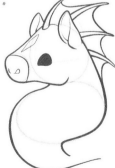

Complete the outline for the body.

10.

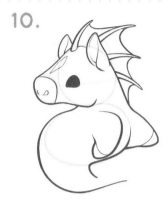

Draw the front legs and hooves and erase your guidelines.

11.

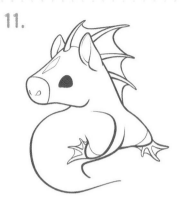

Add fins to the hooves.

12.

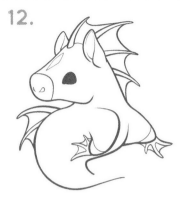

Add fins to the back.

13.

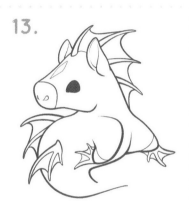

Add fins to the side of the body.

14.

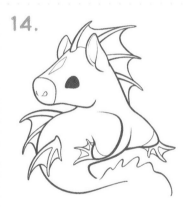

Draw a wavy line around the tail area.

15.

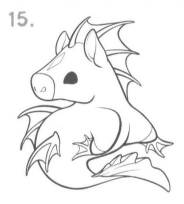

Extend lines connecting the waves back to the body to complete the first tail fin.

16.

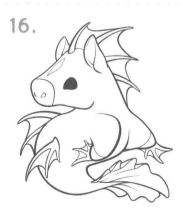

Draw in the lower tail fin.

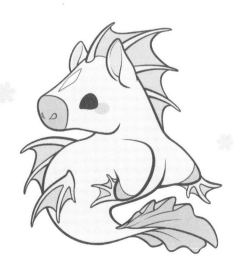

HYDRA

1.

Draw three egg shapes for the heads and add guidelines to each for the facial features.

2.

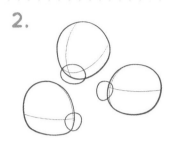

Add a small circle to the front of each head for the nose.

3.

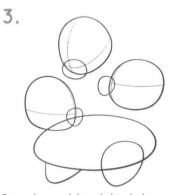

Draw a long oval shape below the lower head for the body and guidelines for the legs.

4.

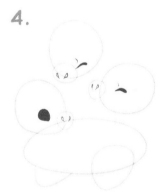

Draw in the facial features.

5.

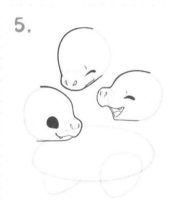

Outline the heads and expressions.

6.

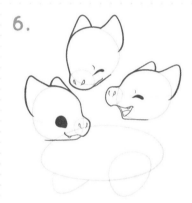

Add horns to the side of each head.

7.

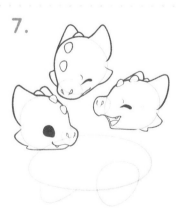

Add scales along each head.

8.

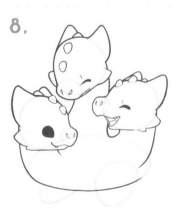

Draw the necks and outline the body.

9.

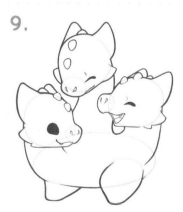

Draw the front legs.

FOLKLORE FACT: *The hydra has many heads. If you cut off one head, two more grow in its place.*

10.

Draw the back legs.

11.

Draw the tail and add scales along the back of each neck, then erase your guidelines.

12.

Add some final details to the character.

MEDUSA

1.
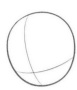

Draw an egg shape for the head and add guidelines for the facial features.

2.
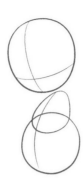

Draw another smaller egg shape below the head for the torso and add a circle below it for the lower half of the body.

3.
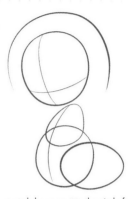

Add an oval shape next to the circle for the lower half of the body, then add an arc over the head following the shape of the head.

4.
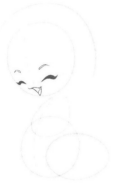

Draw in the facial features.

5.
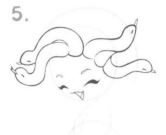

Draw the snakes around the fringe area.

6.
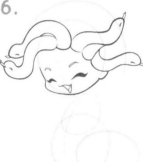

Outline the face.

7.
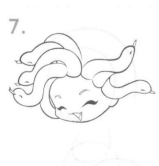

Add more snakes to the front of the head.

8.
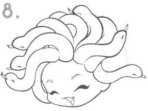

Add even more snakes to the top of the head.

9.
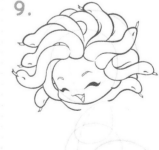

Add yet even more snakes to the back of the head.

10.

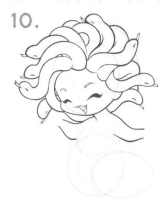

Draw the neck and arms.

11.

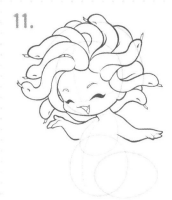

Draw the hands.

12.

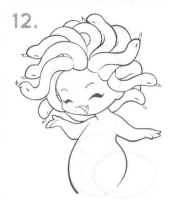

Outline the rest of the body.

13.

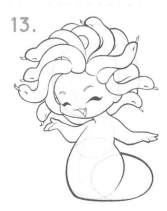

Outline the tail.

14.

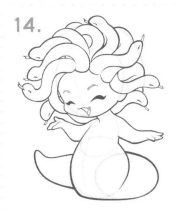

Add more tail to the other side of the character and erase your guidelines.

15.

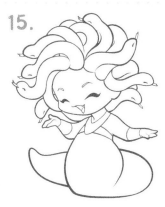

Add some details to the upper half of the body.

16.

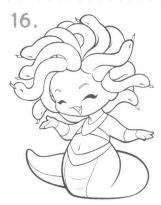

Add more details to the lower half of the body.

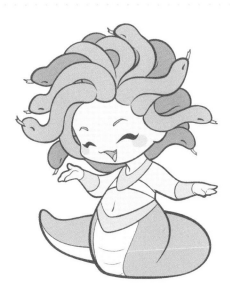

MOTHMAN

1.

Draw a curved rectangle for the head and body and add guidelines for the facial features.

2.

Draw two curves at the top of the head for the feelers.

3.

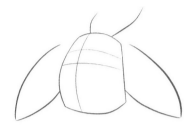

Draw some curves by the sides of the character as guidelines for the wings.

4.

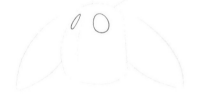

Draw the eyes.

5.

Outline the face.

6.

Add fluff to the chest.

7.

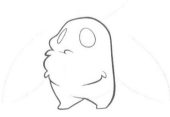

Draw the legs.

8.

Draw the feelers.

9.

Draw the outer feathers on the wings.

10.

Connect the wings back to the body.

11.

Add feathers to the bottom of the wings and erase your guidelines.

12.

Add a pattern of concentric circles to each wing.

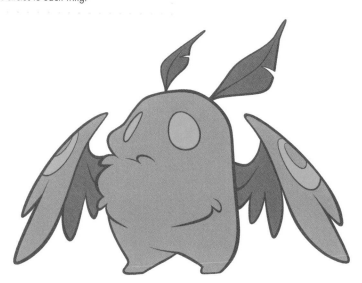

NAGA

1.

Draw an egg shape for the head and add guidelines for the facial features.

2.

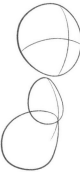

Draw a smaller egg shape below the head for the torso and another egg shape below it for the lower half of the body.

3.

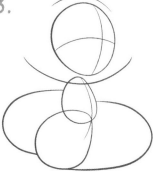

Draw a curve above and below the head and then curves to the left and right of the body as guides for the tail.

4.

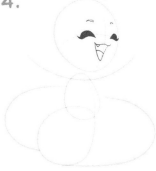

Draw in the facial features.

5.

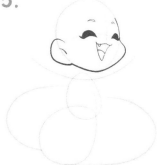

Outline the face.

6.

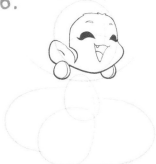

Draw the hairline and add a pair of earrings.

7.

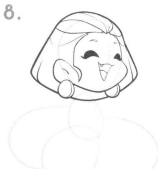

Draw the general shape of the hair.

8.

Add details to the hair.

9.

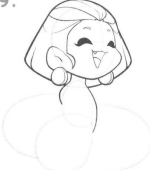

Outline the torso.

10.

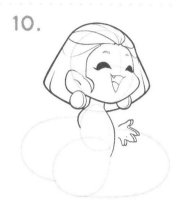

Draw the hands.

11.

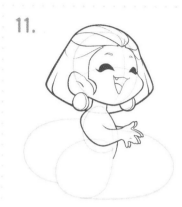

Draw the arms.

12.

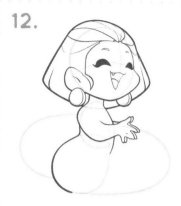

Draw the curve of the back going down to the base of the character.

13.

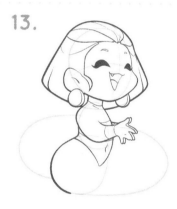

Add accessories to the torso.

14.

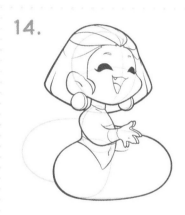

Draw the tail curving around the right side of the character.

15.

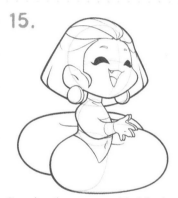

Draw the tail curving around the left side of the character all the way back to the other side. Erase your guidelines.

16.

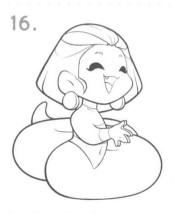

Draw the tip of the tail peeking out from behind the character.

17.

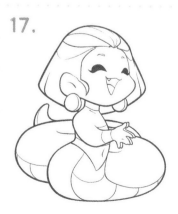

Add some final details to the character.

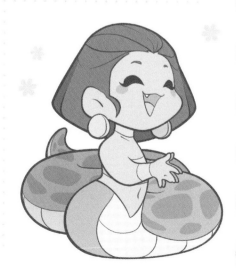

PHOENIX

1.

Draw a circle for the head and add guidelines for the facial features.

2.

Draw an oval shape below the head for the body and another smaller oval shape for one of the legs.

3.

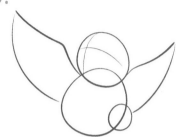

Extend two curves from each side of the body and add two arcs underneath for the wings.

4.

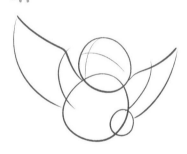

Draw a curve within each of the wing guides.

5.

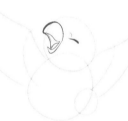

Draw in the facial features.

6.

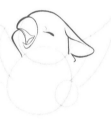
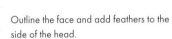

Outline the face and add feathers to the side of the head.

7.

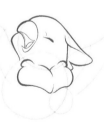

Give the phoenix a fluffy, feathery chest.

8.

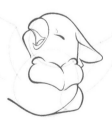

Outline the body.

9.

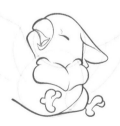

Draw the claws.

10.

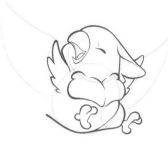

Follow the guidelines and draw the inner feathers of the wings.

11.

Draw the outer feathers of the wings.

12.

Draw a curve for the tail starting from the base of the character. Erase your guidelines.

13.

Add another feather to the tail and a feather to the head.

QUETZALCOATL

1.

Draw an egg shape for the head and add guidelines for the facial features.

2.

Draw a smaller egg shape by the front of the face for the nose and add a larger oval shape below the head for the body.

3.

Extend a line from the side of the body and an arc underneath for the wings.

4.

Outline the forehead and the nose.

5.

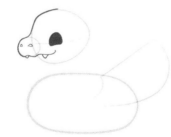

Draw in the facial features.

6.

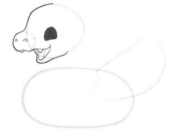

Draw the mouth and the jaw of the quetzalcoatl.

7.

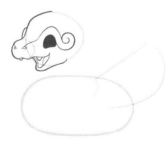

Add details to the face such as the eyebrows and patterns.

8.

Add feathers to the side of the head.

9.

Outline the body.

10.

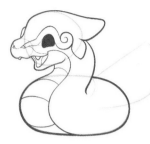

Add details along the belly of
the character.

11.

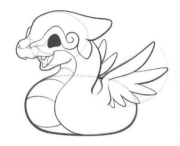

Draw the wings and erase your guidelines.

12.

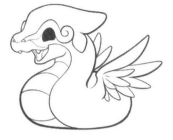

Add feathers to the inner sections of
the wings.

13.

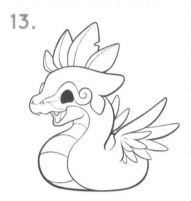

Add feathers to the top of the head.

14.

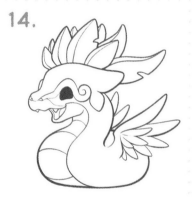

Add a second layer of feathers to the top
of the head.

15.

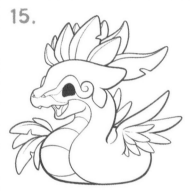

Draw the tip of the tail peeking out from
behind the character.

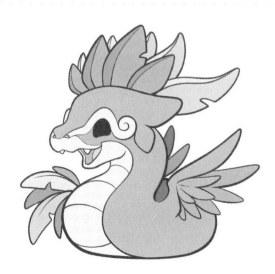

WYVERN

1.

Draw a circle for the head and add guidelines for the facial features.

2.

Draw an egg shape intersecting with a circle below the head for the body.

3.

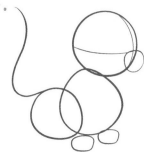

Draw a small circle at the front of the face for the nose and two small oval shapes by the base of the character for the feet. Add a long curve at the back as a guide for the tail.

4.

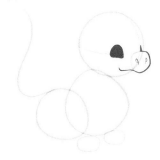

Draw in the facial features.

5.

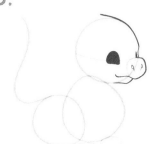

Outline the face.

6.

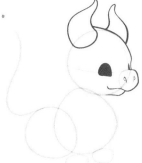

Add a horn to each side of the head.

7.

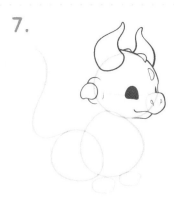

Draw a horn around the cheek area and scales along the forehead.

8.

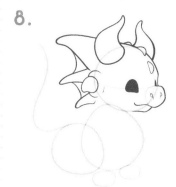

Draw fins at the back of the head.

9.

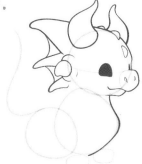

Outline the front of the body.

FOLKLORE FACT: *A wyvern, also called a dragonet, is a small, dragon-like creature that mimics a dragon's powers on a smaller scale.*

10.

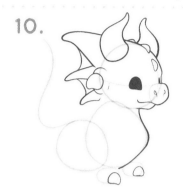

Draw nails for the arms.

11.

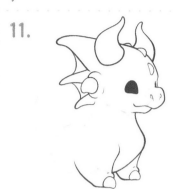

Draw the arms.

12.

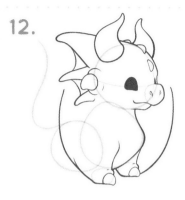

Draw curves attached to the arms for the wings.

13.

Draw the rest of the wings.

14.

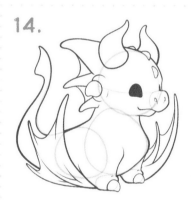

Draw the tail and erase your guidelines.

15.

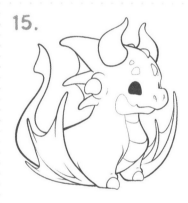

Add some final details to the character.

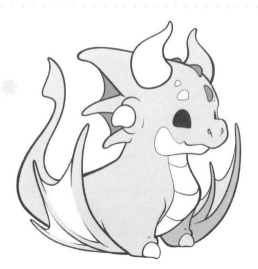

FELINES AND CANINES

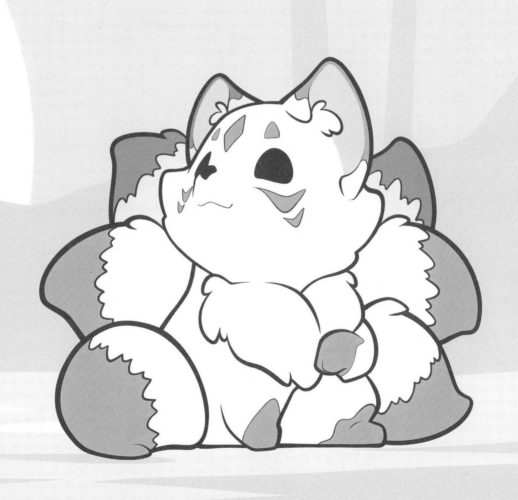

ARALEZ

1.

Draw an egg shape for the head and add guidelines for the facial features.

2.

Draw an oval shape below the head for the body and add two smaller oval shapes inside it for the thigh and foot.

3.

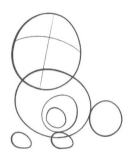

Add two small egg shapes below the body for the other legs and a larger oval shape at the back for the tail.

4.

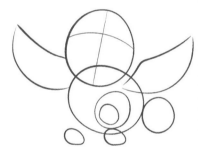

Extend two curves from each side of the body and add two arcs underneath for the wings.

5.

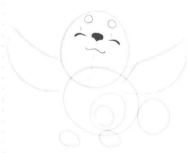

Draw in the facial features.

6.

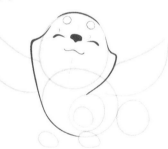

Outline the head and extend the curve down to the chest.

7.

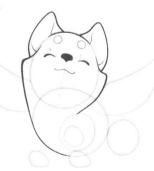

Draw the ears.

8.

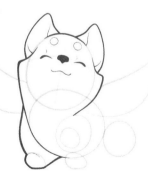

Draw the first foot and extend two curves back to the body for the leg.

9.

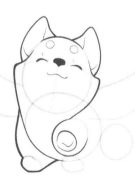

Using the guidelines, draw the raised foot and leg.

FOLKLORE FACT: *In Armenian mythology, the aralez descended from the sky to lick the wounds of dead heroes so they could resurrect after war.*

10.

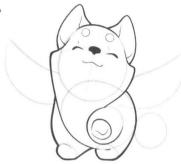

Complete the body by drawing in the back leg.

11.

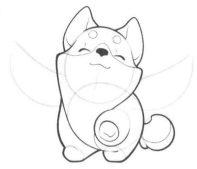

Draw the tail.

12.

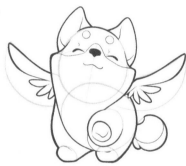

Follow the guidelines and draw the inner feathers of the wings.

13.

Draw the outer feathers of the wings and erase your guidelines.

CERBERUS

1.

Draw three circles for the heads and add guidelines for the facial features.

2.

Add curves to the front of the faces for the snouts.

3.

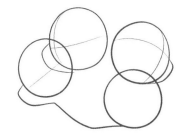

Add a circle below the third head and extend a curve from the circle to the first head for the body.

4.

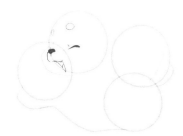

Draw in the facial features of the second head.

5.

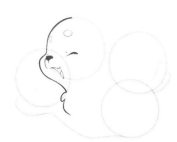

Outline the face.

6.

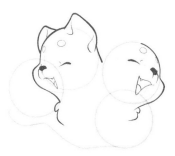

Draw the ears.

7.

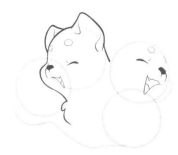

Draw in the facial features of the third head.

8.

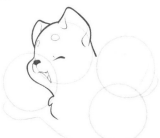

Outline the face.

9.

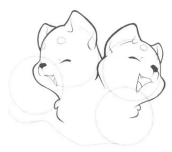

Draw the ears and complete the face.

10.

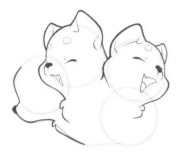

Outline the side profile of the face of the first head.

11.

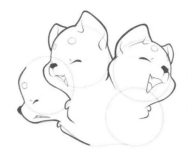

Draw in the facial features.

12.

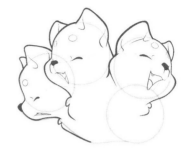

Draw the ears.

13.

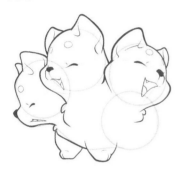

Draw the front legs.

14.

Complete the body by drawing in the back legs. Erase your guidelines.

15.

Draw the tail.

16.

Add some final details to the character and you're done!

CHIMERA

1.

Draw a rounded square shape for the lion's head and add guidelines for the facial features.

2.

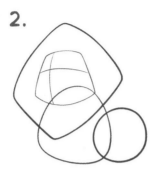

Draw a diamond shape around the head for the mane and add an oval shape and a circle below it for the body.

3.

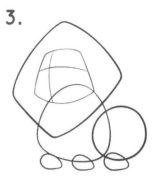

Draw three small egg shapes below the body for the feet.

4.

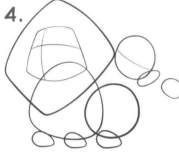

Draw a small circle next to the mane for the goat's head and add guidelines for the facial features. Add an oval shape to the front of this face and another one next to it for the snake's head.

5.

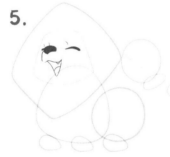

Draw in the facial features of the lion's head.

6.

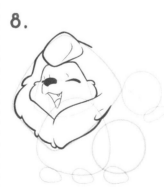

Add a fringe to the top of the head.

7.

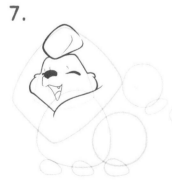

Outline the face.

8.

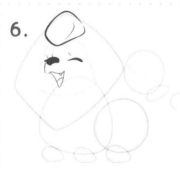

Using the guidelines, draw in the mane and add some additional curves to the outline for the fur.

9.

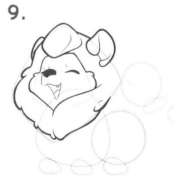

Draw the ears.

10.

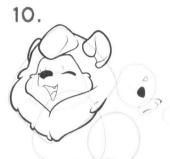

Draw in the facial features of the goat's head.

11.

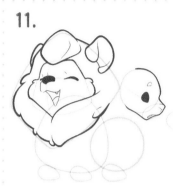

Outline the face.

12.

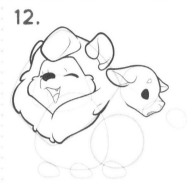

Draw the ears.

13.

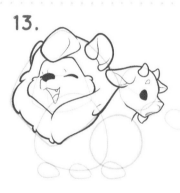

Draw the neck, horns, and goatee of the goat's head.

14.

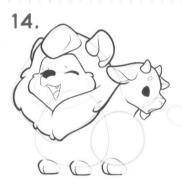

Draw the feet.

15.

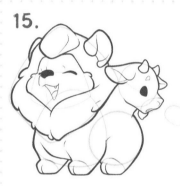

Complete the rest of the body.

16.

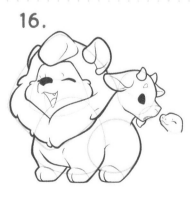

Draw the snake's head and facial features. Erase your guidelines.

17.

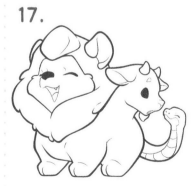

Draw the snake's body.

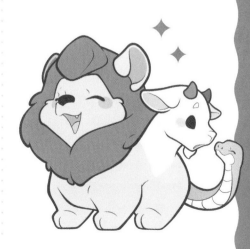

CÙ-SÌTH

1.

Draw a circle for the head and add guidelines for the facial features.

2.

Draw an egg shape intersecting with a circle below the head for the body.

3.

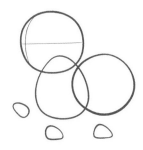

Draw three egg shapes below the body for the feet.

4.

Add a circle to the lower front half of the head for the snout and a curve at the back for the tail.

5.

Draw in the facial features.

6.

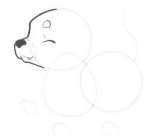

Outline the face.

7.

Draw the ears.

8.

Draw some neck fluff.

9.

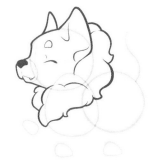

Draw more neck fluff surrounding it.

FOLKLORE FACT: *According to folklore, the Cù-sith haunts the Scottish Highlands and its loud screech can be heard from miles away, even out at sea.*

10.

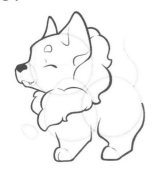

Draw the legs.

11.

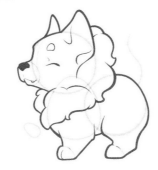

Complete the body.

12.

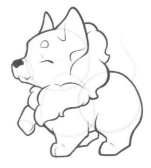

Draw in the other legs.

13.

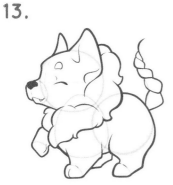

Draw one half of the braids for the tail following the guidelines.

14.

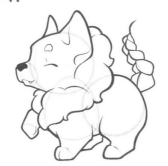

Draw in the other half of the braids for the tail, then erase your guidelines.

15.

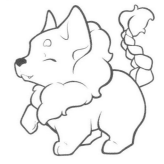

Draw the tip of the tail.

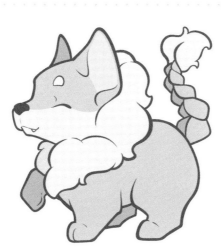

ENFIELD

1.

Draw a circle for the head and add guidelines for the facial features.

2.

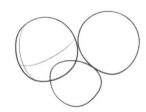

Draw an egg shape and a circle below the head for the body.

3.

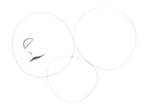

Draw the eye.

4.

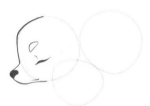

Outline the side profile of the face.

5.

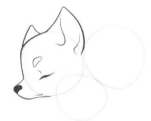

Draw the ears.

6.

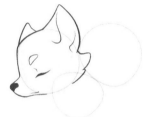

Add fur to the cheeks.

7.

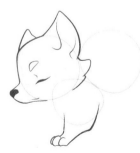

Draw the first front leg starting from the center of the egg shape.

8.

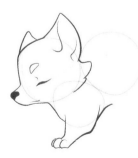

Draw the upper body of the enfield.

9.

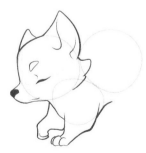

Draw the other front leg.

10.

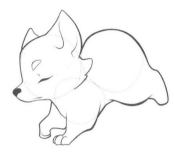

Draw the hind leg and erase your guidelines.

11.

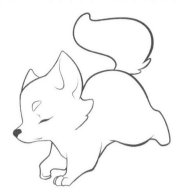

Draw the tail.

12.

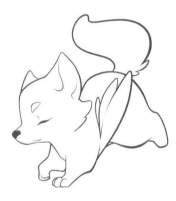

Draw the feathers of the wings.

13.

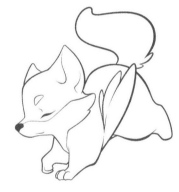

Add some final details to the character.

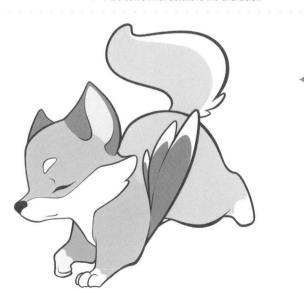

KITSUNE

1.

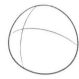

Draw a circle for the head and add guidelines for the facial features.

2.

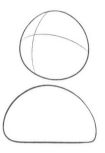

Draw half an oval shape below the head for the body.

3.

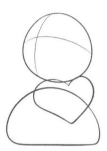

Draw a heart shape as a guide for the chest fur.

4.

Outline the forehead and draw in the facial features.

5.

Draw the ears.

6.

Outline the rest of the face.

7.

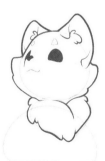

Using the guidelines, draw the chest fur and add some additional curves along the outline to make it look fluffier.

8.

Draw a raised front leg.

9.

Draw the other front leg.

10.

Outline the rest of the body and erase your guidelines.

11.

Draw the first tail.

12.

Draw another tail on the other side.

13.

Keep adding more tails until the empty space is filled.

14.

Add some final details to the character.

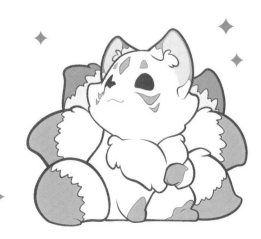

KLUDDE

1.

Draw a rounded square shape for the head and add guidelines for the facial features.

2.

Draw a circle intersecting with an egg shape below the head for the body.

3.

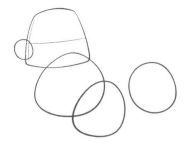

Add a small circle to the front of the face for the nose and a larger circle to the back for the tail.

4.

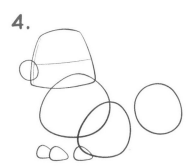

Add three oval shapes to the base of the character for the feet.

5.

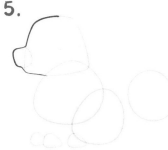

Using the guidelines, outline the face.

6.

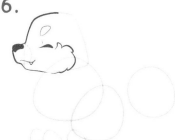

Draw in the facial features.

7.

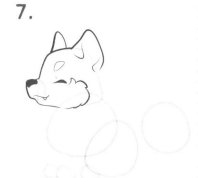

Draw the ears.

8.

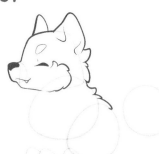

Draw the back and add some additional curves along the outline to make it look fluffier.

9.

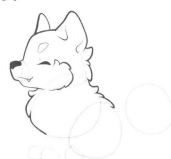

Draw the chest and once again add some additional curves along the outline to make it look fluffier.

10.

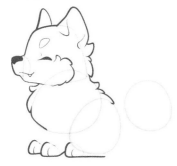

Draw the feet.

11.

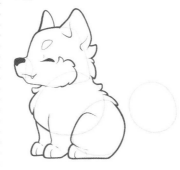

Complete the body by drawing in the back leg.

12.

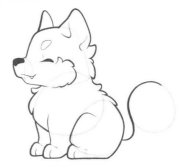

Draw a curve to indicate the general shape of the tail.

13.

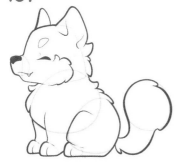

Close up the curve and complete the tail. Erase your guidelines.

14.

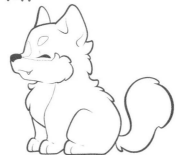

Mark out the patterns on the kludde.

15.

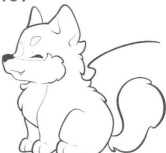

Draw the upper half of the wing.

16.

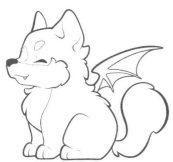

Draw the lower half of the wing.

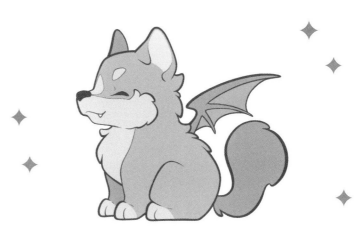

MANTICORE

1.

Draw a rounded square shape for the head and add guidelines for the facial features.

2.

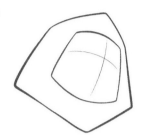

Draw a hexagon around the head for the mane, making the lower half wider than the upper half.

3.

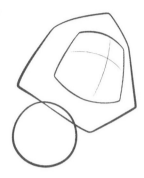

Add a circle below the head for the hind leg.

4.

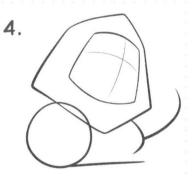

Draw a line along the base of the character and a curve on the other side for the other leg, then add another curve right next to it for the tail.

5.

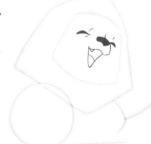

Draw in the facial features.

6.

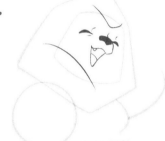

Mark the top and bottom of the face with curves.

7.

Outline the face.

8.

Draw the hair at the top of the head.

9.

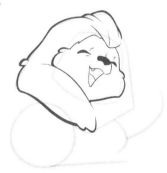

Draw one half of the mane.

10.

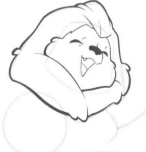

Complete the other half of the mane.

11.

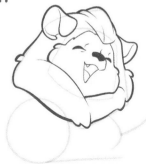

Draw the ears.

12.

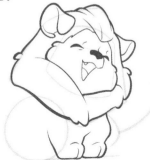

Draw the front legs.

13.

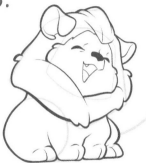

Draw the back legs.

14.

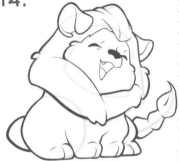

Draw the tail and erase your guidelines.

15.

Draw the wings.

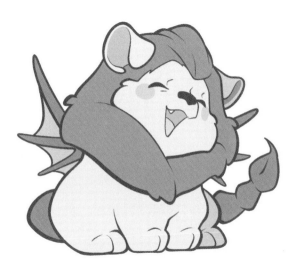

MERLION

1.

Draw a circle for the head and add guidelines for the facial features.

2.

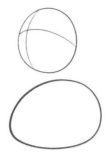

Draw a large oval below the head.

3.

Draw a curve over the head as a guide for the mane, and another curve right below the face for the tail.

4.

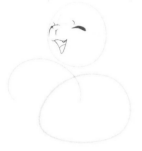

Draw in the facial features.

5.

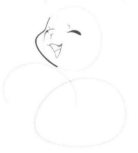

Outline the face.

6.

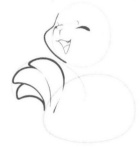

Following the guide, draw one half of the tail fin facing the left.

7.

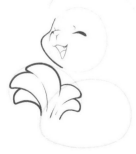

Draw the other half of the tail fin facing the right.

8.

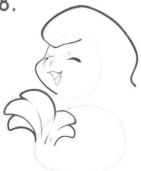

Outline the top of the mane.

9.

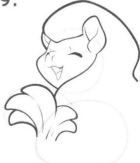

Draw the ears.

10.

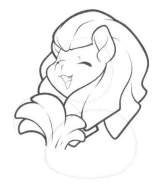

Finish the rest of the mane.

11.

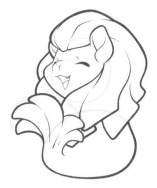

Draw the tail and erase your guidelines.

12.

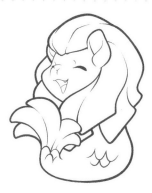

Add scales to the tail.

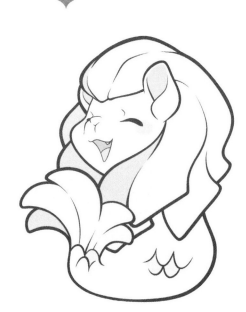

NEKOMATA

1.

Draw a rounded square shape for the head and add guidelines for the facial features.

2.

Draw an oval shape below the head for the body.

3.

Add three small oval shapes to the base of the character for the feet.

4.

Draw a heart shape as a guide for the chest fur and add two curves to the back as guides for the tails.

5.

Draw in the facial features.

6.

Outline the forehead and the nose.

7.

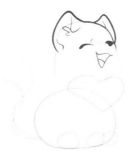

Draw the ears.

8.

Draw the cheeks.

9.

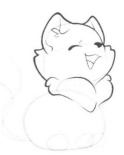

Using the guidelines, draw the chest fur and add some additional curves along the outline to make it look fluffier.

10.

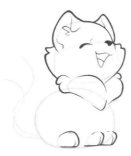

Draw the feet.

11.

Complete the outline for the body.

12.

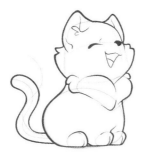

Using the guide, draw the first tail.

13.

Draw the second tail behind the first one and erase your guidelines.

14.

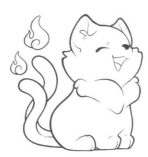

Draw flames above each tail.

ORTHRUS

1.

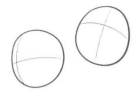

Draw two oval shapes for the heads and add guidelines for the facial features.

2.

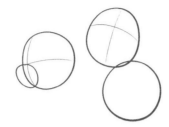

Draw a circle below the second head and add a smaller circle to the front of the first head.

3.

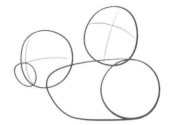

Draw a curve intersecting both heads as a guideline for the body.

4.

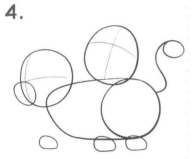

Add three small oval shapes to the base of the character for the feet, as well as one at the back for the head of the snake.

5.

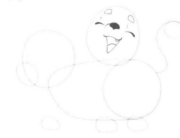

Draw in the facial features of the second head.

6.

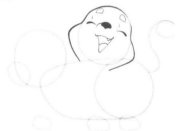

Outline the face.

7.

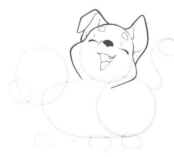

Draw the ears.

8.

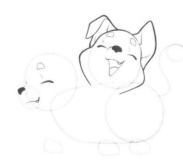

Draw the facial features of the first head.

9.

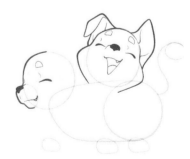

Outline the side profile of the face.

10.

Draw the ears.

11.

Draw the neck and torso of the orthrus.

12.

Draw the front legs.

13.

Complete the body by drawing in the back legs.

14.

Add some final details to the character.

15.

Using the guides, draw the face of the snake.

16.

Connect the snake head to the body and erase your guidelines.

17.

Add details to the snake.

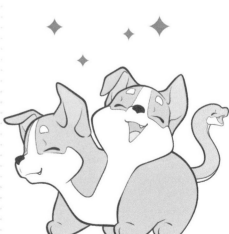

SPHINX

1.

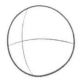

Draw a circle for the head and add guidelines for the facial features.

2.

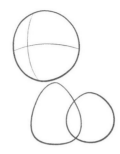

Draw an egg shape intersecting with a circle below the head for the body.

3.

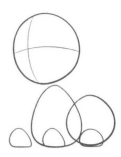

Add three egg shapes to the base of the body for the feet.

4.

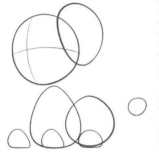

Add a small oval shape at the back of the character for the tail as well as a larger oval shape at the back of the head as a guide for the hair.

5.

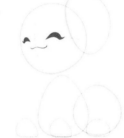

Draw in the facial features.

6.

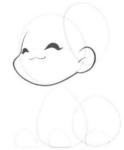

Outline the face and ear.

7.

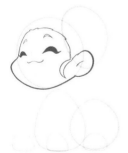

Draw the hairline.

8.

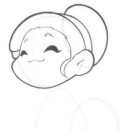

Draw the general shape of the hair.

9.

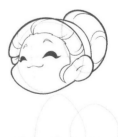

Add details to the hair.

10.

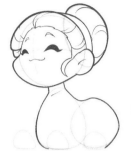

Outline the body.

11.

Draw the feet.

12.

Draw the arms and legs.

13.

Add more hair to the back of the head.

14.

Add accessories to the neck and torso.

15.

Draw the tail and erase your guidelines.

16.

Add wings to the back.

17.

Add another layer of feathers to the wings.

TATZELWURM

1.

Draw a circle for the head and add guidelines for the facial features.

2.

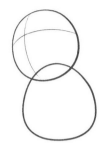

Draw an egg shape below the head for the body.

3.

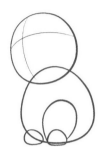

Draw two small oval shapes for the feet and one larger oval shape for the leg.

4.

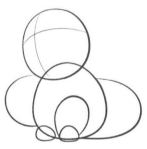

Draw a curve by each side of the character with the right half being slightly lower than the left half.

5.

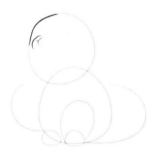

Outline the forehead and the nose.

6.

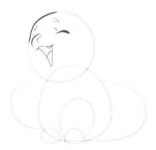

Draw in the facial features.

7.

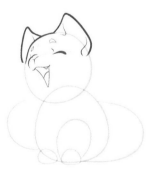

Draw the ears.

8.

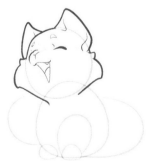

Draw the cheeks.

9.

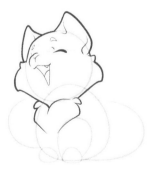

Draw the chest fur.

FOLKLORE FACT: *With a cat-like face and a serpent's body, the tatzelwurm warns Europeans of its approach with a high-pitched shriek.*

10.

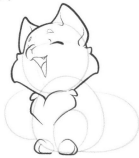

Draw the feet.

11.

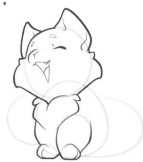

Draw the legs.

12.

Outline the rest of the body, starting with the tail curving around the right side of the character.

13.

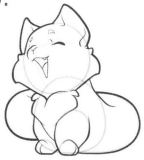

Draw the tail curving around the left side of the character all the way back to the other side. Erase your guidelines.

14.

Draw the tip of the tail peeking out from behind the character.

15.

Add some final details to the character.

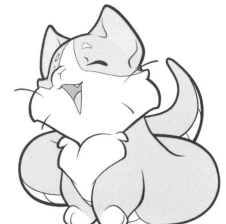

WEREWOLF

1.

Draw a circle for the head and add guidelines for the facial features.

2.

Draw an egg shape within another larger egg shape below the head for the leg and body, respectively.

3.

Draw two small oval shapes by the base of the character for the feet.

4.

Draw an eye and eyebrow.

5.

Outline the face.

6.

Draw the ears.

7.

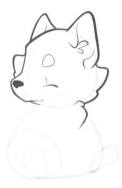

Draw the cheeks and chest fur.

8.

Draw the feet.

9.

Outline the body.

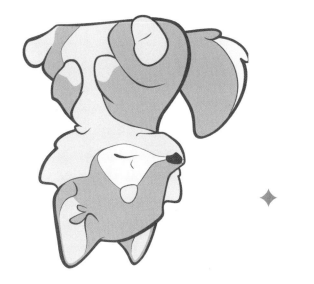

Mark out the patterns on the werewolf.

Draw the tail.

13.

12.

Draw the arms and erase your guidelines.

Draw the legs.

11.

10.

FOLKLORE FACT: *Werewolves have a very heightened sense of sight, smell, and hearing and are known to turn lightning fast.*

HOOVES AND HORNS

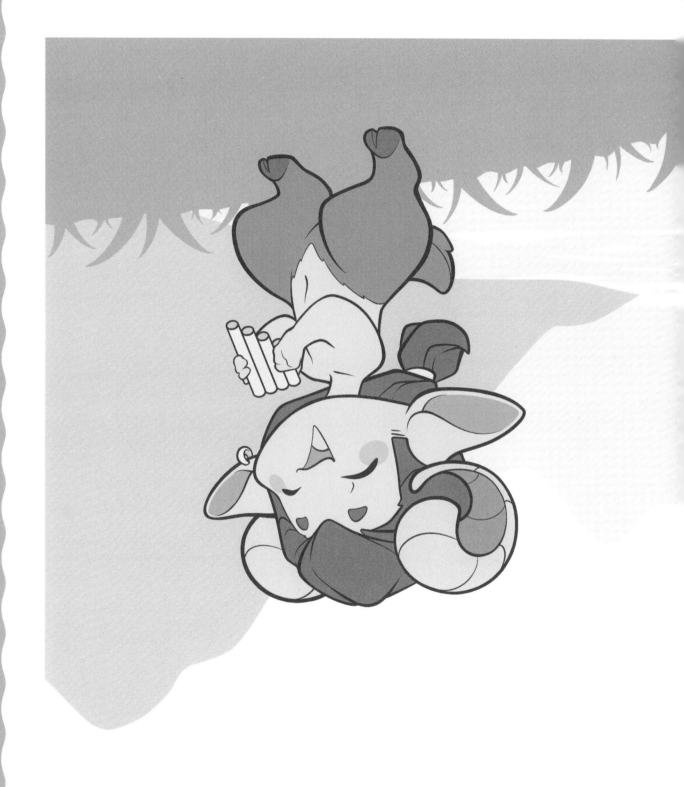

CATOBLEPAS

1.

Draw an egg shape for the head and add guidelines for the facial features.

2.

Add two more oval shapes intersecting with the head and each other for the body and hind leg.

3.

Draw four smaller shapes below the body for the feet and a small circle at the back for the tail.

4.

Add guides for the horns.

5.

Draw the nose.

6.

Extend the nose back to the face and add a curve over it for the fringe.

7.

Add horns to each side of the nose.

8.

Using the guidelines, draw the upper half of the body.

9.

Add detail to the fringe.

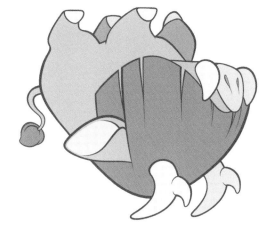

FOLKLORE FACT: A legendary creature from Ethiopia, catoblepas is the African version of a gorgon and its breath can turn people to stone.

10.

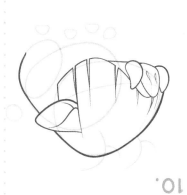

Draw the ear.

11.

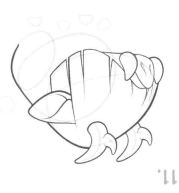

Add horns to the top of the head.

12.

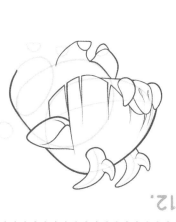

Draw the front half of the body.

13.

Complete the body by drawing in the back legs.

14.

Using the guidelines, draw in the tip of the tail. Erase your guidelines.

15.

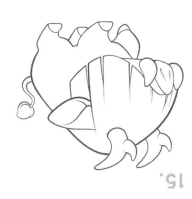

Connect the tip of the tail to the body.

CENTAUR

1.

Draw an oval shape for the head and add guidelines for the facial features.

2.

Draw another smaller egg shape below the head for the torso with a curve extending down the left side.

3.

Add a large oval shape below it for the lower half of the body.

4.

Draw in the facial features.

5.

Outline the face.

6.

Add the hairline.

7.

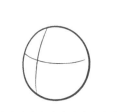

Draw the rest of the hair.

8.

Add details to the hair.

9.

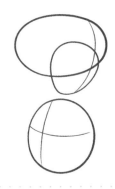

Extend a curve from the neck down to the chest.

10.

Draw in the first arm.

11.

Draw in the other arm.

12.

Add details to the torso.

13.

Draw the front legs and hooves for the lower half of the body.

14.

Complete the body by drawing in the back legs and erase your guidelines.

15.

Draw the tail.

CUYANCÚA

1.

Draw a circle for the head and add guidelines for the facial features.

2.

Draw an oval shape below it for the body and two small half oval shapes underneath for the feet.

3.

Draw a curve by each side of the character with the right- half being slightly lower than the left- half.

4.

Draw the nose.

5.

Add horns to each side of the nose.

6.

Draw the eyes.

7.

Outline the face.

8.

Draw the ears.

9.

Draw two curves for the general shape of the body.

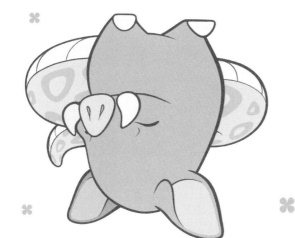

Add some final details to the character.

12.

Draw the feet and complete the legs.

11.

Draw the curves by each side of the cuyancúa for the snake body, ending it with a tail. Erase your guidelines.

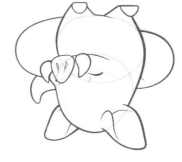

10.

FOLKLORE FACT: *According to Salvadoran legend, cuyancúas announce the arrival of rain and often run in packs.*

HIPPALECTRYON

1.

Draw a circle for the head and add guidelines for the facial features.

2.

Draw an egg shape intersecting with a circle below the head for the body.

3.

Draw a circle at the front of the face for the nose and a long oval shape by the side of the body for the wing.

4.

Using the guidelines, outline the head.

5.

Draw in the facial features.

6.

Draw the ear.

7.

Draw a mane along the top of the head.

8.

Draw the legs and the front half of the body.

9.

Draw the back half of the body.

10.

Draw a claw at the end of the back leg.

11.

Draw the front half of the wings.

12.

Draw the back half of the wings and erase your guidelines.

13.

Draw some curves at the back for the tail. The largest curve should be at the top and the smallest at the bottom.

14.

Close up each curve to create the tail feathers.

15.

Add details to the tail.

ICHTHYOCENTAUR

1.

Draw an egg shape for the head and add guidelines for the facial features.

2.

Draw another smaller egg shape below the head for the torso and add a curve through the left side of the body.

3.

Add an oval shape below it for the lower half of the body and draw two small oval shapes on each side for the hands.

4.

Draw two egg shapes around the bottom half of the body for the legs.

5.

Draw in the facial features.

6.

Outline the head and replace the ear with a fin.

7.

Draw the general outline of the hair.

8.

Add details to the hair.

9.

Draw the neck and add some hair to the back of the head.

10.

Draw the hands.

11.

Draw the arms and a curve along the front of the body.

12.

Draw the torso and add a cuff around each wrist.

13.

Draw the front legs and hooves for the lower half of the body.

14.

Draw two curves converging the body into a tail. Erase your guidelines.

15.

Draw two curves splitting at the tip of the tail.

16.

Using the curves, draw the tail.

17.

Add extra fins to the tail.

JACKALOPE

1.

Draw a circle for the head and add guidelines for the facial features.

2.

Draw a long oval shape below the head for the body and attach a circle to the front of the head as well as the back of the body for the nose and tail, respectively.

3.

Draw a curve at the top of the head as a guide for the horn.

4.

Draw the eyes.

5.

Draw the rest of the face.

6.

Draw the ears.

7.

Draw the body.

8.

Add fluff to the chest and cheek.

9.

Draw the arms.

FOLKLORE FACT: *A mythological warrior- rabbit from Wyoming, the jackalope is easily tempted into a hunter's hands by a glass of whiskey.*

10.

Draw the legs and feet.

11.

Draw the tail.

12.

Mark out the patterns on the jackalope.

13.

Draw the first horn and erase your guidelines.

14.

Draw another horn behind the first one.

MINOTAUR

1.

Draw a circle for the head and add guidelines for the facial features.

2.

Draw an oval shape below the head for the body.

3.

Draw a curve around the neck area for the fur.

4.

Draw the nose.

5.

Add a nose ring to the nose.

6.

Draw in the facial features.

7.

Outline the face.

8.

Draw the ears.

9.

Draw a horn on each side of the head.

FOLKLORE FACT: *Although superbly strong, the minotaur's weakness is that it is constantly hungry.*

10.

Add fur around the neck.

11.

Draw the chest.

12.

Draw the arms.

13.

Draw two curves for the legs.

14.

Draw the feet and erase your guidelines.

15.

Add some final details to the character.

OPHIOTAURUS

1.

Draw a rounded square shape for the head and add guidelines for the facial features.

2.

Draw an oval shape below the head for the body.

3.

Draw a large circle encompassing the body.

4.

Draw the nose.

5.

Draw the rest of the face.

6.

Draw a horn on each side of the head.

7.

Draw the ears.

8.

Outline the body.

9.

Draw the legs.

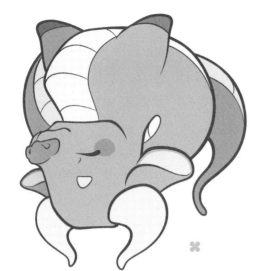

Add some final details to the character.

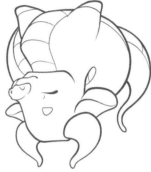

12.

Draw the tip of the tail peeking out from behind the character, then erase your guidelines.

11.

Using the guide, draw the tail circling around the back of the character.

10.

FOLKLORE FACT: *In Greek mythology, if you turn the entrails of an ophiotaurus you can defeat the gods.*

PEGASUS

1.

Draw a circle for the head and add guidelines for the facial features.

2.

Draw an oval shape below the head for the body and a smaller oval shape for one of the front legs.

3.

Draw a curve around the head for the mane and a small circle at the front of the head for the nose.

4.

Extend two curves from each side of the body and add two arcs underneath for the wings.

5.

Outline the face.

6.

Draw in the facial features.

7.

Draw the ears and the neck.

8.

Using the guide, draw the mane of the pegasus.

9.

Add details to the mane.

FOLKLORE FACT: *A winged horse in Greek mythology, Pegasus was the offspring of the sea god Poseidon and Medusa.*

10.

Draw the front half of the body.

11.

Complete the body by drawing in the back legs.

12.

Add wings to the character and erase your guidelines.

13.

Draw the tail.

14.

Add details to the tail.

QILIN

1.

Draw a circle for the head and add guidelines for the facial features.

2.

Draw a small oval shape at the front of the face for the nose and add a few lines to the top of the head as guides for the horns.

3.

Draw an egg shape intersecting with an oval shape below the head for the body.

4.

Draw an oval shape at the back of the character for the tip of the tail and connect it to the body.

5.

Outline the forehead and the nose.

6.

Draw in the facial features.

7.

Draw the eyebrows and the cheeks.

8.

Draw a horn at the top of the head.

9.

Draw the ear.

10.

Draw the front legs.

11.

Draw the back legs.

12.

Complete the body by drawing in the tail.

13.

Draw the mane along the top of the head.

14.

Continue the mane down the back of the neck to the tip of the tail.

15.

Draw the tip of the tail and erase your guidelines.

16.

Add some final details to the character.

17.

Draw a whisker extending from each cheek area.

SATYR

1.

Draw an egg shape for the head and add guidelines for the facial features.

2.

Draw a smaller egg shape below the head for the torso and a circle on each side of the head for the horns.

3.

Add two circles side by side below the torso for the legs.

4.

Draw four small oval shapes for the hands and feet, and a rectangular shape between the hands for the instrument.

5.

Draw in the facial features.

6.

Outline the face.

7.

Draw the fringe as well as the top of the head.

8.

Add details to the hair.

9.

Draw the ears.

10.

Using the guides, draw the horns.

11.

Draw the instrument.

12.

Draw the hands.

13.

Draw the arms.

14.

Draw the hair at the back with a ponytail at the end.

15.

Draw the lower half of the body.

16.

Draw the feet and erase your guidelines.

17.

Draw the tail and add some final details to the character.

UNICORN

1.

Draw an egg shape for the head and add guidelines for the facial features.

2.

Draw a circle by the front of the face for the nose.

3.

Draw another egg shape below as well as two curves to connect it to the head. These will be the guides for the body.

4.

Draw the face.

5.

Draw a horn at the center of the forehead.

6.

Draw the ear.

7.

Draw the hairline.

8.

Complete the fringe.

9.

Draw the upper layer of the mane.

10.

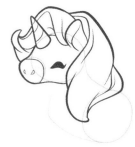

Draw the lower layer of the mane.

11.

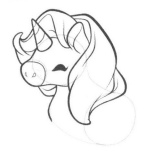

Draw the front half of the body.

12.

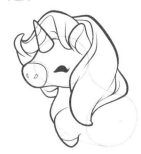

Draw the first leg and hoof.

13.

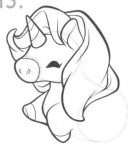

Draw the second leg.

14.

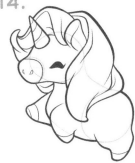

Draw the hind leg and the back of the body. Erase your guidelines.

15.

Draw the second hind leg.

16.

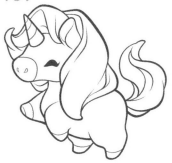

Draw the tail.

17.

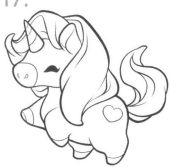

Add some final details to the character.

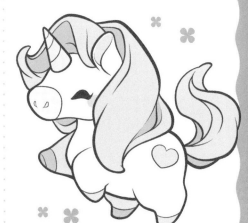

EARTH, WATER, AND SUBTERRANEAN CREATURES

BIGFOOT

1.

Draw a curved rectangle for the head and body and add guidelines for the facial features.

2.

Add two oval shapes for the hands and two rectangles for the feet.

3.

Draw in the facial features.

4.

Outline the face.

5.

Using the guidelines, draw in the body and add some additional curves to the outline for the fur.

6.

Draw the ears.

7.

Draw the legs, once again adding additional curves to the outline for the fur.

8.

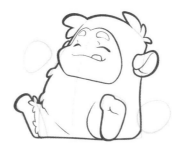

Draw the feet.

9.

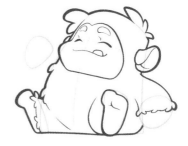

Draw the first arm.

FOLKLORE FACT: *Also known as Sasquatch, Bigfoot has been seen roaming the northwest United States and Canada and is famously shy.*

10.

Complete the arm by drawing in the hand.

11.

Draw in the other arm and erase your guidelines.

12.

Complete the other arm by drawing in the hand.

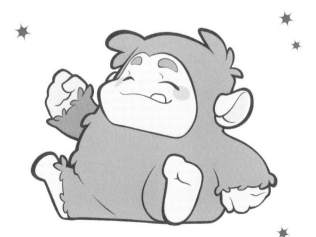

CECAELIA

1.

Draw an egg shape for the head and add guidelines for the facial features.

2.

Draw another smaller egg shape below the head for the torso and add an oval shape below it for the lower half of the body.

3.

Add a snowman shape to each side of the head and extend four curves from the body for the tentacles.

4.

Draw in the facial features.

5.

Outline the face.

6.

Add the hairline and give the character a fringe.

7.

Draw the top of the head.

8.

Add locks of hair to the back.

9.
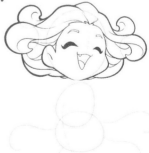

Draw in the rest of the hair.

10.

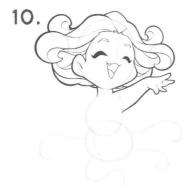

Draw the neck and the first arm.

11.

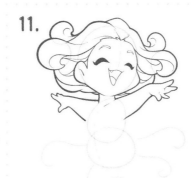

Draw in the other arm.

12.

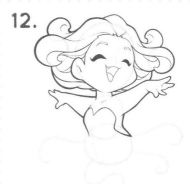

Draw the torso.

13.

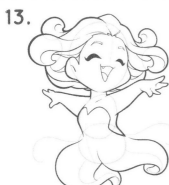

Following the shape of the guiding curves, draw the tentacles in the front.

14.

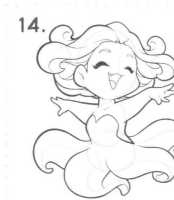

Following the shape of the guiding curves, draw the tentacles at the side. Erase your guidelines.

15.

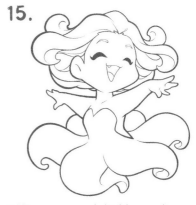

Add two more curves behind the cecaelia to indicate more tentacles at the back.

16.

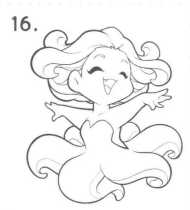

Add some final details to the character.

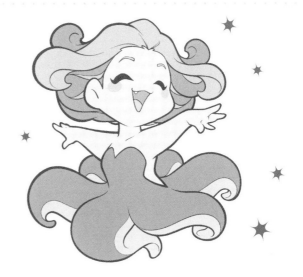

CYCLOPS

1.

Draw an oval shape for the head and add guidelines for the facial features.

2.

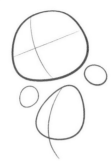

Draw an egg shape below the head for the torso and add two smaller egg shapes by each side for the hands.

3.

Draw in the facial features.

4.

Outline the head.

5.

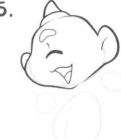

Add a horn to the top of the head.

6.

Outline the general shape of the body.

7.

Add details for the clothes.

8.

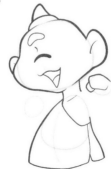

Draw the upper half of one of the fists.

9.

Complete the fist and add a curve for the forearm.

10.

Complete the arm.

11.

Draw the upper half of the other fist.

12.

Complete the fist.

13.

Draw the other arm.

14.

Draw the legs and erase your guidelines.

15.

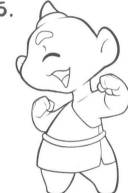

Add a belt for the clothes.

16.

Add some final details to the character.

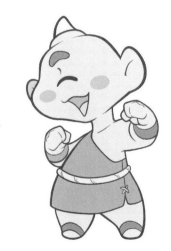

ELF

1.

Draw an egg shape for the head and add guidelines for the facial features.

2.

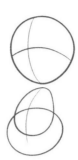

Draw another smaller egg shape below the head for the torso and add an oval shape below it for the lower half of the body.

3.

Draw a circle at the top of the head for the fringe and two small egg shapes at each side of the body for the hands.

4.

Draw in the facial features.

5.

Outline the face.

6.

Draw the ears.

7.

Draw the brim of the hat.

8.

Add the fringe.

9.

Draw the hat.

10.

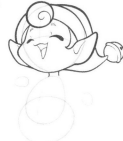

Add a bell to the end of the hat.

11.

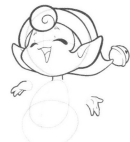

Draw the hands.

12.

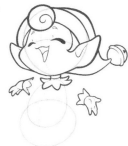

Draw a collar and cuffs for the clothes.

13.

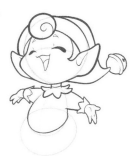

Draw the torso and arms.

14.

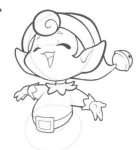

Add a belt to the waist.

15.

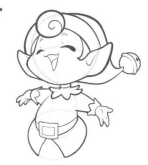

Draw the hem of the shirt.

16.

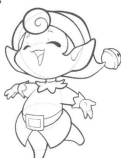

Draw the legs and erase your guidelines.

17.

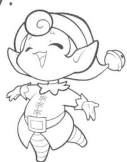

Add some final details to the character.

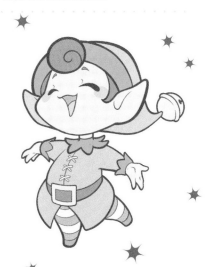

FAIRY

1.

Draw an egg shape for the head and add guidelines for the facial features.

2.

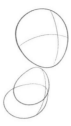

Draw another smaller egg shape below the head for the torso and add an oval shape below it for the lower half of the body.

3.

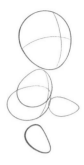

Draw two more egg shapes below for the legs.

4.

Add two small circles on each side for the hands and a large curve over the head following the shape of the head for the hair.

5.

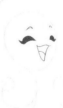

Draw in the facial features.

6.

Outline the face and neck.

7.

Draw the ears and hairline.

8.

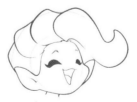

Draw the general shape of the hair.

9.

Add details to the hair.

10.

Draw the hands.

11.

Draw the arms.

12.

Draw the upper half of the body.

13.

Draw the skirt.

14.

Draw the legs and erase your guidelines.

15.

Outline the wings.

16.

Draw more locks of hair at the back.

17.

Add some final details to the character.

GENIE

1.

Draw an egg shape for the head and add guidelines for the facial features.

2.

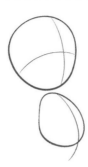

Draw another smaller egg shape below the head for the torso.

3.

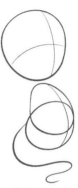

Add an oval shape below it for the lower half of the body and another curve attached to it for the smoke.

4.

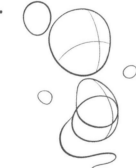

Draw an oval shape at the top of the head for the hair and two smaller oval shapes by each side of the torso for the hands.

5.

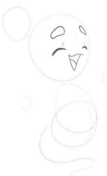

Draw in the facial features.

6.

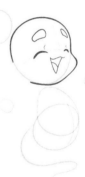

Outline the head.

7.

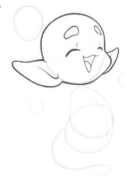

Draw the ears.

8.

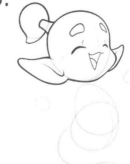

Draw the hair.

9.

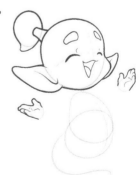

Draw the hands.

FOLKLORE FACT: *Aside from granting wishes, genies can change shape, fly through the air, or become invisible.*

10.

Draw the arms.

11.

Outline the rest of the body.

12.

Complete the smoke.

13.

Remove the guidelines.

14.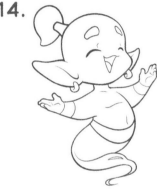

Add accessories such as earrings and cuffs.

15.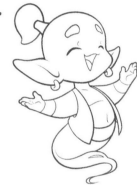

Give the genie a vest.

GNOME

1.

Draw an egg shape with a flat base for the head and body and add guidelines for the facial features.

2.

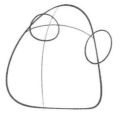

Add an egg shape to the front of the face and another to the side along the horizontal facial guideline.

3.

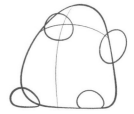

Add egg shapes to the base of the body for the feet.

4.

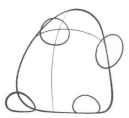

Draw a longer oval shape above the head. This will be the tip of the hat.

5.

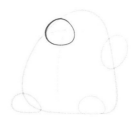

Draw the nose.

6.

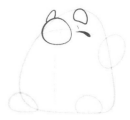

Draw the eyes and eye brows.

7.

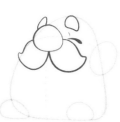

Draw the moustache.

8.

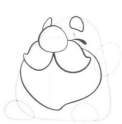

Draw the beard.

9.

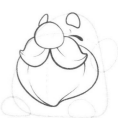

Add details to the moustache and beard.

10.

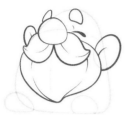

Draw the ears.

11.

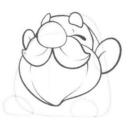

Draw the bottom edge of the hat.

12.

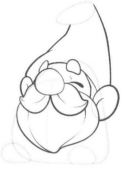

Draw the hat.

13.

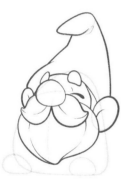

Add a fold to the hat right at the top.

14.

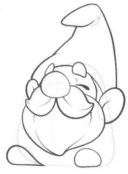

Draw the feet and erase your guidelines.

15.

Draw the body.

GOBLIN

1.

Draw an egg shape for the head and add guidelines for the facial features.

2.

Draw another smaller egg shape below the head for the torso.

3.

Add another egg shape below it for the lower half of the body.

4.

Draw a long oval shape next to the head.

5.

Draw in the facial features.

6.
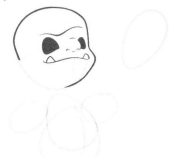

Outline the head.

7.
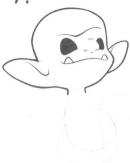

Draw the ears and neck.

8.
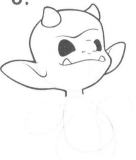

Add horns to each side of the head.

9.
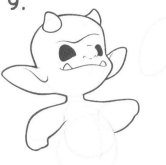

Draw the arms and hands.

10.

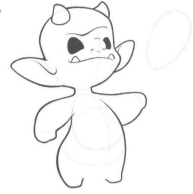

Draw the front and back of the body.

11.

Draw a belt and a cloth.

12.

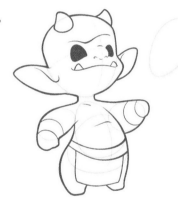

Add some final details to the character.

13.

Draw a club and erase your guidelines.

14.

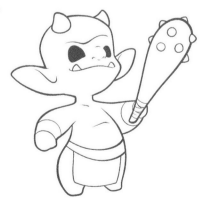

Add details such as wraps and spikes to the club.

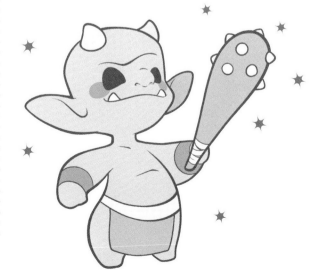

GOLEM

1.

Draw a rounded square shape for the head and add guidelines for the facial features. Add a small sketch to draw a flower on top of the head.

2.

Draw in the facial features.

3.

Outline the face while adding some angles to make it look more rock-like.

4.

Draw the legs.

5.

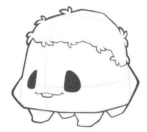

Draw a grassy patch at the top of the head.

6.

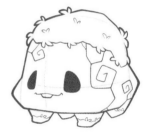

Add some details and patterns to the character.

7.

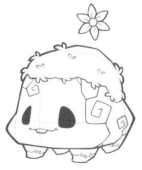

Using the guidelines, draw a flower above the head. Erase your guidelines.

8.

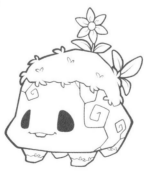

Draw the stem and leaves of the flower. Add some leaves around the character.

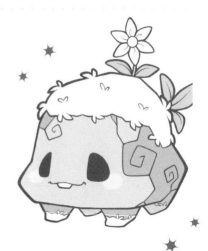

LOCH NESS

1.

Draw a circle for the head and add guidelines for the facial features.

2.

Draw a large oval shape below the head for the body.

3.

Draw an eye and outline the head.

4.

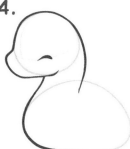

Outline the front half of the body.

5.

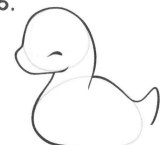

Outline the back of the body and draw in the tail.

6.

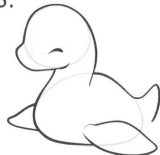

Draw a fin on each side of the body.

7.

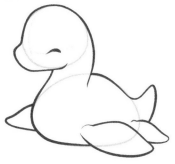

Add a smaller fin right next to the larger one, then erase your guidelines.

8.

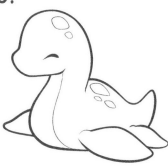

Add some final details to the character.

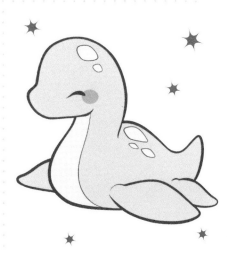

IMP

1.

Draw an oval shape for the head and add guidelines for the facial features.

2.

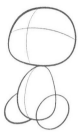

Draw a longer oval shape below the head for the body and add two smaller oval shapes on each side of the body for the legs.

3.

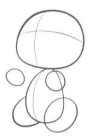

Add a circle to each side of the body for the hands.

4.

Draw a circle next to the leg for the tail and a curve on each side of the head as guides for the horns.

5.

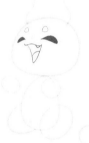

Draw in the facial features.

6.

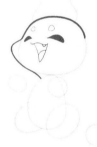

Outline the head.

7.

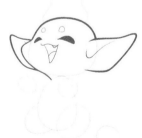

Draw the ears.

8.

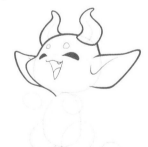

Draw the horns.

9.

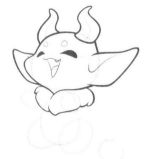

Draw some neck fluff.

10.

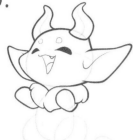

Draw the arms.

11.

Add fingernails and details to the hands.

12.

Draw the tummy.

13.

Draw the legs.

14.

Draw hooves for the feet.

15.

Draw the wings.

16.

Draw the tip of the tail and erase your guidelines.

17.

Connect the tip of the tail to the body.

KAPPA

1.

Draw a circle for the head and add guidelines for the facial features.

2.

Draw an egg shape below the head for the body and add a curve to the left connecting the head to the body.

3.

Add a long oval shape to the top of the head and two small oval shapes to the base of the character for the feet.

4.

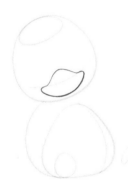

Draw the beak.

5.

Draw in the facial features.

6.

Outline the oval shape at the top of the head.

7.

Draw a petal pattern going all the way around the oval shape.

8.

Outline the face.

9.

Outline the body.

10.

Draw the arms.

11.

Draw the legs.

12.

Draw the shell and the tail, then erase your guidelines.

13.

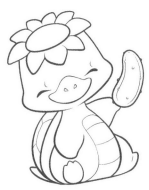

Draw a cucumber in one hand and add some final details to the character.

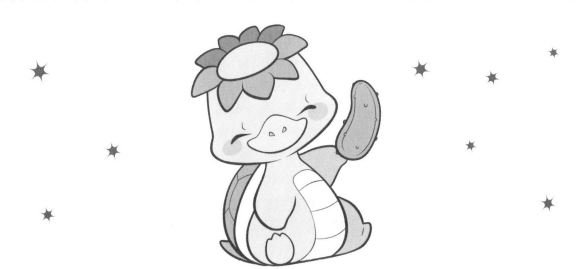

LEPRECHAUN

1.

Draw a circle for the head and add guidelines for the facial features.

2.

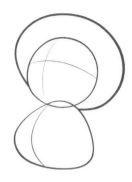

Draw an egg shape below the head for the body and add a curve surrounding the head for the brim of the hat.

3.

Draw in the facial features.

4.

Outline the face.

5.

Draw the ear.

6.

Mark out the hairline for the beard.

7.

Draw a bow around the neck area.

8.

Draw the first hand.

9.

Draw in the rest of the arm, taking note to mark where the sleeves for the jacket and shirt end.

10.

Draw the beard, adding some additional curves along the outline to make it look fluffier.

11.

Using the guide, draw the brim of the hat.

12.

Draw the rest of the hat.

13.

Outline the body.

14.

Give the character a long coat and erase your guidelines.

15.

Draw the other arm and hand, taking note to mark where the sleeves for the jacket and shirt end.

16.

Add some final details to the character.

17.

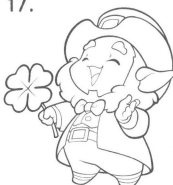

Give the character a four-leaf clover.

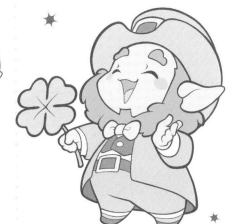

LEVIATHAN

1.

Draw a circle for the head and add guidelines for the facial features.

2.

Draw another circle below the head for the torso and add a small circle to the front of the face for the nose.

3.

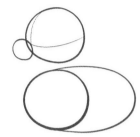

Draw a large oval shape for the body.

4.

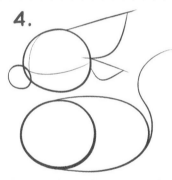

Draw some lines and arcs emerging from the side of the head to mark where the fins will be, and add a curve to the back of the body for the tail.

5.

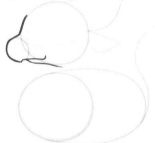

Using the guides, outline the face.

6.

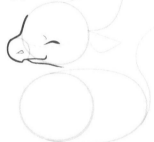

Draw in the facial features.

7.

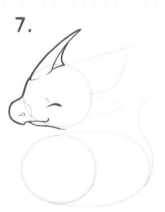

Add a fin to the top of the head.

8.

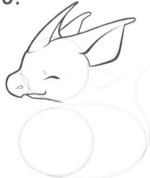

Add a fin to each side of the head.

9.

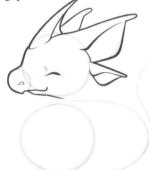

Add another fin right under the previous one.

FOLKLORE FACT: In Jewish mythology, Leviathans have superhuman strength, speed, and stamina, and have superior intelligence.

10.

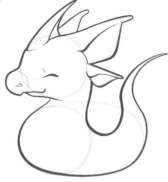

Using the guides, outline the body. Erase your guidelines.

11.

Draw a fin on each side of the body.

12.

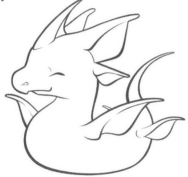

Draw a smaller set of fins closer to the tail.

13.

Draw the tail fins.

14.

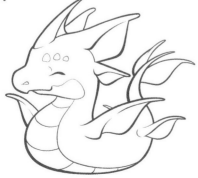

Add some final details to the character.

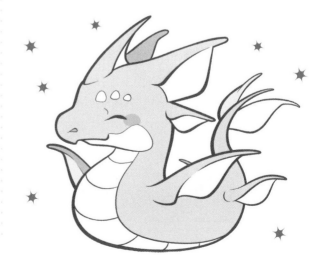

MERMAID

1.

Draw an egg shape for the head and add guidelines for the facial features.

2.

Draw a smaller egg shape below the head for the torso and a larger egg shape below it for the lower half of the body.

3.

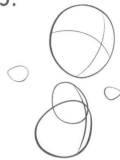

Draw a small oval shape on each side of the torso for the hands.

4.

Draw in the facial features.

5.

Outline the face.

6.

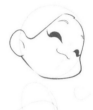

Draw the hairline.

7.

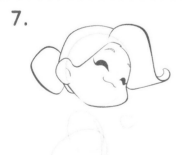

Draw the general shape of the hair.

8.

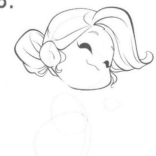

Add details to the hair.

9.

Draw the neck and a curve for the front of the torso.

10.

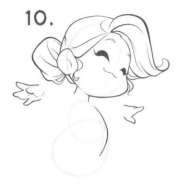

Draw the hands.

11.

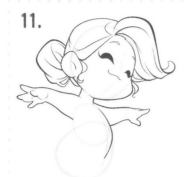

Draw the arms.

12.

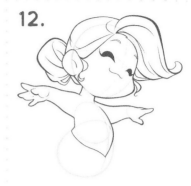

Complete the torso.

13.

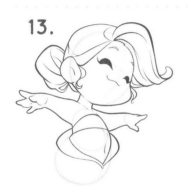

Add a top and some fins along the waist.

14.

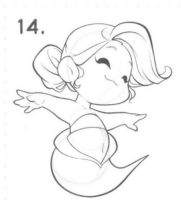

Draw the tail and erase your guidelines.

15.

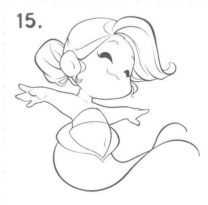

Draw two curves splitting at the tip of the tail.

16.

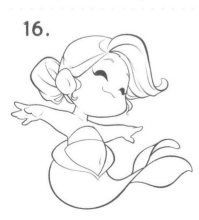

Using the curves, draw the tail.

17.

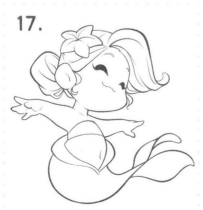

Add a starfish, or any other accessory, to the hair.

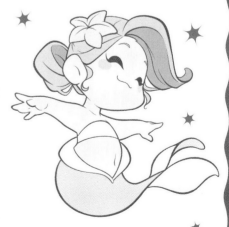

MUMMY

1.

Draw a rounded square shape for the head and add guidelines for the facial features.

2.

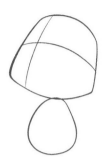

Draw a small egg shape below the head for the body.

3.

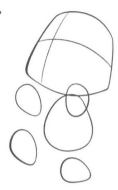

Add four oval shapes as guides for the hands and feet.

4.

Draw the eyes.

5.

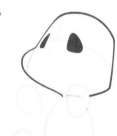

Outline the head.

6.

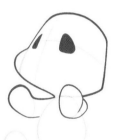

Draw the arms.

7.

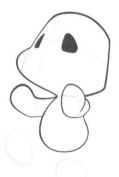

Outline the body.

8.

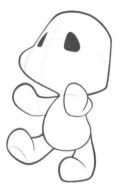

Draw the legs and erase your guidelines.

9.

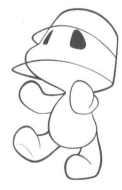

Draw two curves across the face to mark where the bandages are to be placed.

FOLKLORE FACT: *Mummies are said to be very strong, so be sure to leave them alone! They'll put a curse on anyone who disturbs them.*

10.

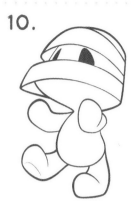

Complete the bandages.

11.

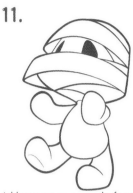

Add more curves across the face to indicate more bandages are wrapped around.

12.

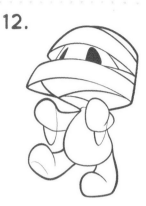

Draw a curve going around each wrist.

13.

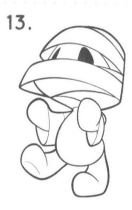

Use the curve to draw a sleeve around each arm.

14.

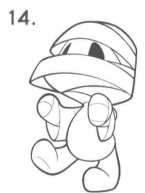

Draw more curves around the hands to indicate more bandages are wrapped around.

15.

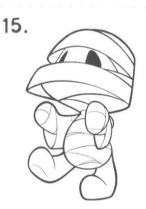

Draw curves going around the body.

16.

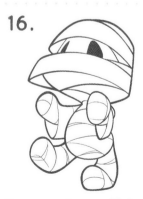

Draw curves going around the legs. The curves should always follow the contour of the surface.

17.

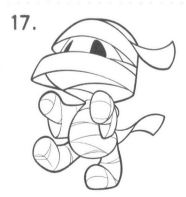

Add excess bandages sticking out of the back.

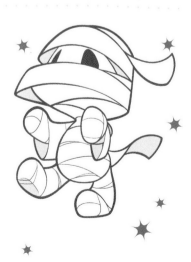

TREANT

1.

Draw a curved rectangle for the head and body and add guidelines for the facial features.

2.

Add a small extension on each side for the arms.

3.

Draw a curve over the head.

4.

Draw in the facial features.

5.

Outline the body.

6.

Draw the top of the stump, adding some thick jagged edges along the way.

7.

Draw the base of the treant, once again adding thick, jagged edges along the way. Erase your guidelines.

8.

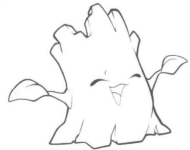

Draw a leaf on each side of the character.

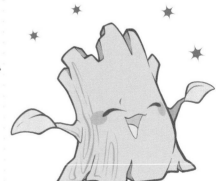

KRAKEN

1.

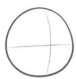

Draw a circle for the head and add guidelines for the facial features.

2.

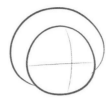

Draw a curve surrounding the head and add a line at the base of the character.

3.

Draw in the facial features.

4.

Draw the first tentacle.

5.

Draw the second tentacle.

6.

Draw the mantle of the kraken. Add a fin to the top of the mantle, then erase your guidelines.

7.

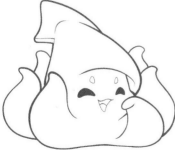

Add another set of fins to each side. Add one final set of fins to each side.

8.

Mark out the patterns on the tentacles.

VAMPIRE

1.

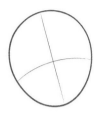

Draw an egg shape for the head and add guidelines for the facial features.

2.

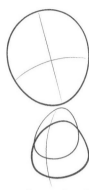

Draw a smaller egg shape below the head for the torso and another egg shape below it for the lower half of the body.

3.

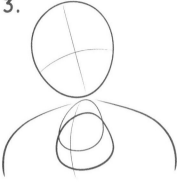

Draw an arc on each side of the body for the cape.

4.

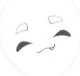

Draw in the facial features.

5.

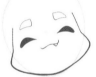

Outline the face.

6.

Draw the ears.

7.

Draw the top of the head.

8.

Draw the hairline.

9.

Add details to the hair.

10.

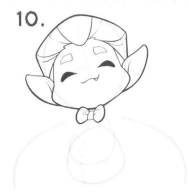

Add a bow tie around the neck.

11.

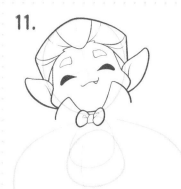

Draw the collar of the cape.

12.

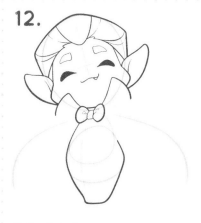

Outline the body.

13.

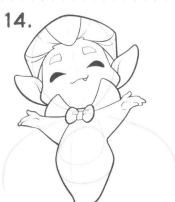

Draw the arms.

14.

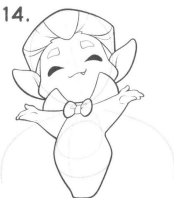

Draw the hands.

15.

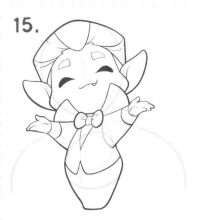

Add some final details to the character.

16.

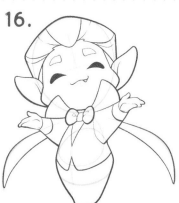

Draw the outer material of the cape, then erase your guidelines.

17.

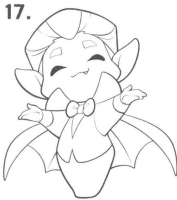

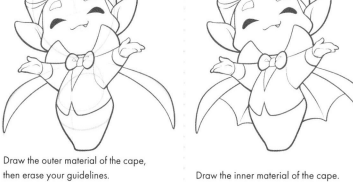

Draw the inner material of the cape.

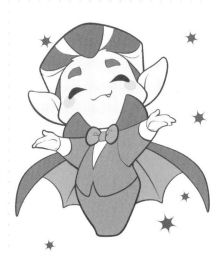

WENDIGO

1.

Draw a circle for the head and add guidelines for the facial features.

2.

Draw a curved V shape below the head as a guide for the chest fur.

3.

Add two circles to the base of the character for the legs.

4.

Add two oval shapes around the circles for the placement of the feet.

5.

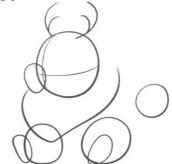

Draw an egg shape at the front of the face and another at the back. Add double curves to the top of the head.

6.

Draw in the facial features.

7.

Outline the face.

8.

Add a horn to each side of the head.

9.

Draw the ears.

10.

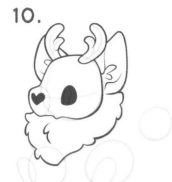

Using the guidelines, draw the chest fur and add some additional curves along the outline to make it look fluffier.

11.

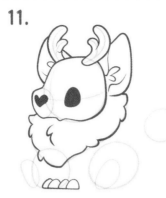

Draw the nails for the hands.

12.

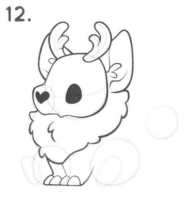

Draw the arms.

13.

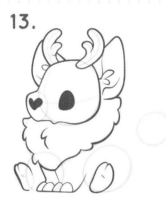

Draw the feet.

14.

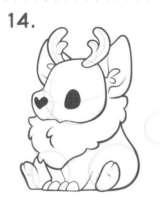

Draw the back legs and complete the outline for the body.

15.

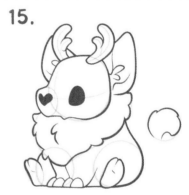

Draw the tip of the tail, then erase your guidelines.

16.

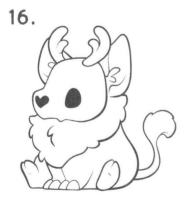

Connect the tail to the body.

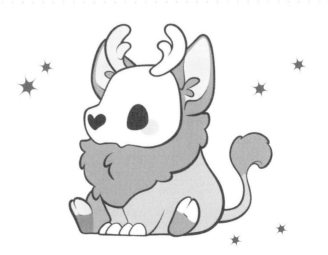

YETI

1.

Draw a curved rectangle for the head and body and add guidelines for the facial features.

2.

Draw guides for the arms and feet.

3.

Draw in the facial features.

4.

Outline the face.

5.

Using the guidelines, draw in the body and add some additional curves to the outline for the fur.

6.

Draw the ears.

7.

Draw the arms and erase your guidelines.

8.

Draw in the legs.

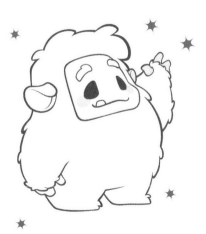